OUT OF RUBBLE

For my parents, William and Ursula Slavick,
and all those who work for peace.

Susanne Slavick

OUT OF RUBBLE

CHARTA

Design
Daniela Meda

Editorial Coordination
Filomena Moscatelli

Copyediting
Charles Gute

Copywriting and Press Office
Silvia Palombi

US Editorial Director
Francesca Sorace

Promotion and Web
Monica D'Emidio

Distribution
Anna Visaggi

Administration
Grazia De Giosa

Warehouse and Outlet
Roberto Curiale

Cover
Lida Abdul, *White House*, 2005
video still from 16mm film on DVD
© Lida Abdul, courtesy of the artist and
Giorgio Persano, Turin

*Photo credits, when known or provided, are
included in each image caption.*

We apologize if, due to reasons wholly
beyond our control, some of the photo
sources have not been listed.

Edizioni Charta srl
Milano
via della Moscova, 27 - 20121
Tel. +39-026598098/026598200
Fax +39-026598577
e-mail: charta@chartaartbooks.it

Charta Books Ltd.
New York City
Tel. +1-313-406-8468
e-mail: international@chartaartbooks.it

www.chartaartbooks.it

Acknowledgements

This book grew out of my work as an artist inflamed by the inhumane and inspired by those who survive, rage against or rise above it. I am fortunate to belong to a family who advocate for peace and social justice—my parents, William and Ursula Slavick; my siblings, Lisa, Sarah, Stephen, Madeleine and elin; my partner, Andrew Ellis Johnson; and my son, Ian Horne. Their questions, compassion and actions inform and propel my work. They belong to a larger current of more profound sacrifice and resistance offered by all those "someones" too numerous to acknowledge here—the visible and invisible whose momentum still runs strong. The quest for peace occurs through endeavors daily and eternal, intimate and public, minute and mighty. I hope that this book is one of them, countering the "unmaking" of this world and contributing to its "remaking."

I thank the College of Fine Arts and the Berkman Faculty Development Fund at Carnegie Mellon University for supporting the research and publication preparation for this project. I am indebted to Wisława Szymborska for her poem of "someones" woven throughout my essay and to Holly Edwards for asking us to ask "What If…" in an essay that imagines an alternative. And much appreciation for the editorial eyes of Andrew Ellis Johnson, elin o'Hara slavick and Madeleine Slavick—their multiple lenses focused on a clearer language.

Simone Weil saw in art the most noble of human efforts: to construct and to refrain from destruction. I am deeply grateful to all the artists who work in this spirit and whose works are included in these pages.

Exhibition versions of OUT OF RUBBLE, with works by selected artists and tailored to specific venues, are available to travel. The first will premiere at SPACE Gallery in Pittsburgh, Pennsylvania, December 2, 2011 through February 5, 2012. Please direct inquiries to: slavick@andrew.cmu.edu

OUT OF RUBBLE is a project that reacts to the wake of war—its realities and its representations.

As the United States and its dwindling coalition approaches a decade of war across Iraq and Afghanistan, our questions intensify. Disappointed at the rejection or failure of diplomacy and mired in military rhetoric and force, we probe our motives. Vanquished or victorious at each battle's conclusion, we hope, even vow, that we might never repeat such violence. Yet every war leads to another, and so we repeatedly turn to the rubble.

The responses of the international artists in OUT OF RUBBLE are invariably somber, ranging from tender to unflinching visions. They respond to what remains after the traumas we inflict on ourselves and each other through state-sponsored or individual acts of violence. The paradox of trauma is that experiencing it directly may result in the absolute inability to know it.[1] Artists may "see" horrific and violent events directly or indirectly, wrestling either way with the ability to "know" them, or ultimately represent them. They plunge into the paradox. The images they create are, as Susan Sontag describes in *Regarding the Pain of Others*, no "more than an invitation to pay attention, to reflect, to learn, to examine the rationalizations for mass suffering offered by established powers," asking: "Who caused what the picture shows? Who is responsible? Is it excusable? Was it inevitable?"[2]

Such crucial questions inform and motivate contemporary artists as war and its ensuing wreckage continues to plague the planet. The rubble that each war leaves behind is also carried into the future, whether physically, psychologically, culturally or spiritually. Artists record, remember, reflect, re-purpose and restore that rubble—materially and conceptually, literally and metaphorically. Whether responding personally or collectively, how can artists recognize what has been destroyed and speak to how (or whether) it can be restored? Can their creative efforts redeem or act as empathic restitution? Can their efforts enact or embody recovery from ruin?

Faced with the obliteration of human lives and habitats, the pendulum of response swings wildly from rage and sorrow to compassion and confidence in our capacity to recover. This collection of works uses images, actions, materials and processes that speak to decimation and disintegration and our struggle to resist or overcome it. It represents the aftermath of war in specific

places (Beirut, Berlin, Gaza, Hiroshima, Kabul, Karachi, Nagasaki, Najaf, Sarajevo, Tehran, Tokyo and more) as well as in invented or unidentifiable sites. The chaos of war does not discriminate or differentiate one place from another, nor soldier from civilian. Its rubble bequeaths anonymity, eradicating the defining features of cultures and peoples. Some artists depict such erasure while others counter it by re-injecting or animating the human traces that distinguish time and place.

Reflecting on war from a country with a long history of conflict, the Polish poet Wisława Szymborska wrote: "Reality demands that we mention this: Life goes on." OUT OF RUBBLE presents artists who face this demand; artists whose responses range from the tentative (given the scope of loss) to the blatant (given the severity of impact); artists whose responses mourn the havoc we wreak and atone the atrocities we commit; and artists who create narratives bound up in the crises of truth, striving toward the impossible task of comprehending the incomprehensible, or exposing the lies that lead us to folly. Before and long after the rubble is cleared, they review, anticipate and sometimes lay ground for what needs to be rebuilt.

Susanne Slavick
Pittsburgh, 2010

Contents

THE END AND THE BEGINNING
Wisława Szymborska

After every war
someone has to clean up.
Things won't
straighten themselves up, after all.

Someone has to push the rubble
to the side of the road,
so the corpse-filled wagons
can pass.

Someone has to get mired
in scum and ashes,
sofa springs,
splintered glass,
and bloody rags.

Someone has to drag in a girder
to prop up a wall,
Someone has to glaze a window,
rehang a door.

Photogenic it's not,
and takes years.
All the cameras have left
for another war.

We'll need the bridges back,
and new railway stations.
Sleeves will go ragged
from rolling them up.

Someone, broom in hand,
still recalls the way it was.
Someone else listens
and nods with unsevered head.
But already there are those nearby
starting to mill about
who will find it dull.

From out of the bushes
sometimes someone still unearths
rusted-out arguments
and carries them to the garbage pile.

Those who knew
what was going on here
must make way for
those who know little.
And less than little.
And finally as little as nothing.

In the grass that has overgrown
causes and effects,
someone must be stretched out
blade of grass in his mouth
gazing at the clouds.

"The End and the Beginning,"
from *Miracle Fair: Selected Poems of Wisława Szymborska*,
translated by Joanna Trzeciak. © 2001 by Joanna Trzeciak.
Used by permission of W.W. Norton & Company, Inc.

JOSEPH BEUYS

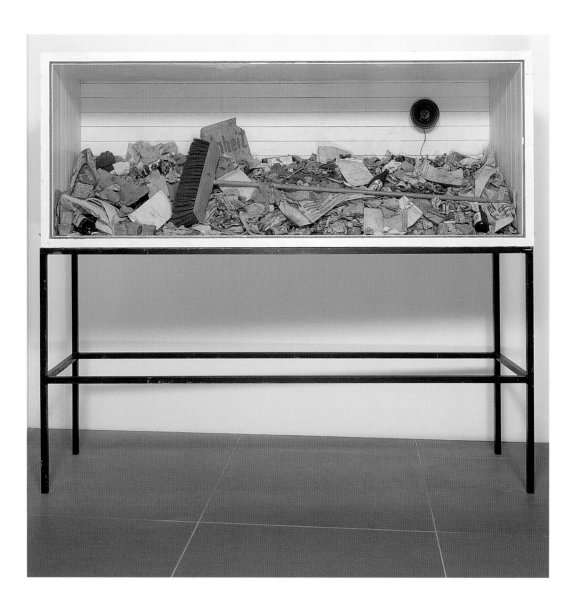

AUSFEGEN (SWEEPING UP) 1972-85
SOUND SCULPTURE WITH MATERIAL FROM AN ACTION BY JOSEPH BEUYS IN BERLIN, MAY 1, 1972.
THE MATERIAL WAS PLACED IN A VITRINE IN 1985 BY ARRANGEMENT OF RENÉ BLOCK.
© 2011 ARTISTS RIGHTS SOCIETY (ARS), NEW YORK / VG BILD-KUNST, BONN
PHOTO: NEUES MUSEUM, NUREMBERG

Susanne Slavick

OUT OF RUBBLE

"Someone" is the heart that repeatedly beats in Wisława Szymborska's poem "The End and the Beginning." This "someone" must clean and straighten up, push the rubble aside, and get mired in the scum and ashes of war. "Someone" must drag a girder, glaze a window and rehang a door, rebuild bridges and railway stations. Szymborska's incantation of "someone" begins almost accusatorily and escalates with each iteration, leading us to ask: Who *is* the "someone" responsible for all these tasks? Someone else—or us?

After that "someone" sweeps up all the wreckage and buries all the carnage, after the cameras are gone and tired arguments discarded, Szymborska speaks matter-of-factly of our incipient boredom, our gradual ignorance and eventual dismissal of every war. Despite the normalcy of forgetting, her poem is a testament against forgetting.[3] The artists in OUT OF RUBBLE join that testament, looking both backward and forward, remembering and foretelling, recriminating and reenacting, reflecting and regenerating.

Some of the artists in OUT OF RUBBLE have survived war or been displaced by it, seen buildings fall, homes destroyed and people die, or come back to ruin when the battles have ceased. Only they can determine if they have more, or less, to translate. Most of the artists in OUT OF RUBBLE have witnessed war from afar, on living room televisions and laptop screens. They have struggled with their response to its violence and aftermath, recognizing their distance from the harm and, unlike Szymborska's "someone," holding no "broom in hand." As either direct or indirect victims, witnesses or contributors to war and its ensuing traumas, artists face a gauntlet of critical and ethical expectations, conditions and prohibitions in reacting to and representing pain, disaster and tragedy.

When making or perceiving images of war and its aftermath, natural and immediate responses include identification or empathy. "There, but for the grace of God, go I" springs to the lips of sympathetic believers and nonbelievers alike. Mieke Bal, in her essay "The Pain of Images," discusses sentimentality and identification as either appropriative or exploitative (in feeling oneself feeling—in order to feel good about oneself).[4] Identification is characterized as an unreflective,

even involuntary response—the rising lump, the sinking stomach—to seeing something emotionally charged. Bal describes its quandaries: that "the viewer identifying with other people's (represented) suffering appropriates the suffering, cancels out the difference between self and other, and in the process, cheapens the suffering." The self subsumed also risks alienation in "becoming" the other, whether motivated by acquisitiveness or generosity. If the vicarious suffering ends up annulling the difference between the actual sufferer and the viewer, the suffering all but disappears, consumed by the commiserating viewer.[5]

And yet suffering elicits empathy and requires witnessing; otherwise, the sufferer becomes further isolated and dehumanized. A host of cultural theorists advocate a qualified and monitored empathy. Geoffrey Hartman considers the empathic response as indispensable in art, but a response that must be checked. He argues that art's "truest reason" is in expanding "the sympathetic imagination while teaching us about the limits of sympathy." In *Empathic Vision*, Jill Bennett sees hubris in colonizing another's experience, as does Leo Bersani in *The Culture of Redemption*—in art's claim to *salvage* damaged experience and thereby redeem life.[6] Bennett further dissects the promotion of a critical and self-reflexive empathy as the most appropriate way to deal with trauma imagery. Addressing the problems of empathy, she summarizes Dominick LaCapra's concept of "*empathic unsettlement* to describe the aesthetic experience of simultaneously *feeling for* another and becoming aware of the distinction between one's own perceptions and the experience of the other."[7] LaCapra maintains that empathy must be "a virtual, not vicarious, experience…in which emotional response comes with respect for the other and the realization that the experience of the other is not one's own."[8] Understanding and conveying that distance, sometimes narrow and sometimes wide—between self and other, artist and subject, viewer and viewed—is one of the many challenges artists face.

Artists wrestle constantly with the failure of images to represent the full complexity of lived reality. In "Psychoanalysis, Culture and Trauma," Cathy Caruth posits the paradox that traumatic experience suggests: "that the most direct seeing of a violent event may occur as an absolute inability to know it."[10] If those who directly experience the traumas of violence are unable to know them, how can artists from afar know or empathize with them? Can such horrific realities even be represented? And if so, how?

The question of how pain can or cannot be expressed is examined in Elaine Scarry's *The Body in Pain*. She describes pain as a medical term, as an aspect of war, torture and other explicitly political acts, and as the most absolute definer of reality. When one is in pain, it is the only reality. That reality, that pain, is inexpressible. Scarry articulates how language is inadequate to describe it and, conversely, how pain actively destroys language, leaving the suffering subject in absolute isolation. She speaks to pain's "unmaking" of

the world and our creative "making" that works against pain and its debasing uses.[11] Facing the paradox of trauma, the incomprehensibility of pain and the invisibility of suffering, the attempt to represent runs many risks. Brecht, in his defense of modern art, speaks to those risks:

> In art there is the fact of failure, and the fact of partial success. Our metaphysicians must understand this. Works of art fail so easily; it is so difficult for them to succeed. One man will fall silent because of lack of feeling; another, because his emotion chokes him. A third frees himself, not from the burden that weighs on him, but only from a feeling of unfreedom. A fourth breaks his tools because they have too long been used to exploit him. The world is not obliged to be sentimental. Defeats should be acknowledged; but one should never conclude from them that there should be no more struggles.[13]

The struggle continues.

Aware (or not) of these critical frameworks, artists persist in serving witness to war, its causes and its costs. *How* we visualize the pain it creates, the loss it imposes, the ruin it leaves, constitutes another critical and ethical minefield. A chorus of voices joined the debate within pre- and post-WWII German Marxism concerning the "aestheticization of tragedy." The primary source for that debate was Walter Benjamin's essay "The Author as Producer" that discussed fashionable photographers' treatment of human misery as an object of consumption.[14] Theodor Adorno amplified (and later amended) the argument: to stylize or make beautiful political realities such as war and violence is to collude with the destruction of the world. Beautifully representing suffering or destruction, turning it into something that can be perceived as art, threatens to make it palatable, perhaps even seductive and pleasurable. If violence becomes appealing, it is unwittingly redeemed and ultimately erased.[15]

Decades later, Ingrid Sischy articulated this anxiety, indicting the formal beauty of Sebastião Salgado's contemporary photographs of people suffering from poverty, disease and famine: "And this beautification of tragedy results in pictures that ultimately reinforce our passivity towards the experience they reveal. To aestheticize tragedy is the fastest way to anaesthetize the feelings of those who are witnessing it. Beauty is a call to admiration, not action."[16] The Uruguayan writer Eduardo Galeano defends and distinguishes Salgado from those whose pictures operate from a charity that humiliates rather than from a solidarity that helps, by questioning structures of power.

> Reality speaks a language of symbols. Each part is a metaphor of the whole. In Salgado's photographs, the symbols disclose themselves from the inside to the outside. The artist does not extract the symbols from his head, to

generously offer them to reality, requiring that they be used. Rather, reality selects the precise moment that speaks most perfectly for it: Salgado's camera denudes it, tears it from time and makes it into image, and the image makes itself symbol—a symbol of our time and our world. These faces that scream without opening their mouths are "other" faces no longer. No longer, for they have ceased being conveniently strange and distant, innocuous excuses for charity that eases guilty consciences. We are all those dead, going back centuries or millennia, who nevertheless remain stubbornly alive—alive down to their profoundest and most painful radiance, who are not pretending to be alive for a photograph.[17]

In saluting Salgado, Galeano excoriates those whose pictures of hell serve only "to confirm the virtues of paradise."[18]

Some artists are oblivious to this minefield of representation, stomping across it. Others tiptoe. Some try to sweep or clear the mines. This minefield of representation is, of course, only metaphorical, but it matters. Can artists avoid its traps, and what can we accomplish if we do or don't? Can we bear witness while doing no further harm? And if so, how?

One way is to interrogate or refute the claim that beauty co-opts and minimizes tragedy. In *Between the Eyes*, David Levi Strauss writes:

The idea that the more transformed or "aestheticized" an image is, the less "authentic" or politically valuable it becomes, is one that needs to be seriously questioned. Why can't beauty be a call to action? The unsupported and careless use of "aestheticization" to condemn artists who deal with politically charged subjects recalls Brecht's statement that "the 'right thinking' people among us, whom Stalin in another context distinguishes from creative people, have a habit of spell-binding our minds with certain words used in an extremely arbitrary sense."

To represent is to aestheticize; that is, to transform. It presents a vast field of choices but it does not include the choice not to transform, not to change or alter whatever is being represented. It cannot be a pure process, in practice. This goes for photography as for any other means of representation.[19]

In all of its aesthetic variety, what can the collection of artworks in OUT OF RUBBLE achieve? As visually and conceptually compelling works, they can create tension and pose questions that activate both artist and audience. They can start by asking: Are we allowed to view what is being exposed?[20] They can help us face the invisibility and inexpressibility of damage to the human psyche and habitat. They can clue us in on our position in relation to what is revealed, how we see it, what we assume and what we should not. *Beautiful Suffering: Photography and the Traffic in Pain*, the 2006 exhibit at Williams

College Museum of Art, tackled such questions through the works on view and the theoretical context of its catalogue. In their joint essay, *Traffic in Pain*, co-curators Mark Reinhardt and Holly Edwards commented on the innocent and durable trust that photographs still enjoy. Questioning that trust can apply to artworks across other media as well. They caution: "That trust can harbor diverse illusions and excuses—for example, that the viewer need look no further to understand distant events; that "structural violence requires only personal emotional response; that the represented pain or calamity has already been resolved and can therefore be dismissed; or that addressing the problem is the privilege or the perquisite of the viewer."[21] Artists assume this privilege, however imperfectly.

SOMEONE, BROOM IN HAND, STILL RECALLS THE WAY IT WAS.

Part of that privilege entails recalling. To some degree, all of the artists in OUT OF RUBBLE forbid our forgetting. **Anselm Kiefer** melds matter and history in facing the unfathomable ruins of war. Born in Germany during the collapse of the Third Reich, he has plumbed the origins, infliction and aftermath of WWII, as well as violence that transcends time and borders. Kiefer is apt to say: "The ruins, the dust, this is where I begin from."[22]

As genocide raced on during the Third Reich, millions of tons of bombs rained on 131 cities and towns of the fatherland, leaving, as described by W.G. Sebald, three and a half million homes destroyed, seven and a half million people homeless, 31.1 cubic meters of rubble for every person in Cologne and 42.8 cubic meters for every inhabitant of Dresden.[23] Such finite quantification points to failure of immense, if not infinite, proportions. Such failure continues to plague humanity and suffuses Kiefer's work as he addresses survival—its miracle and burden. Through physical, metaphorical and symbolic transformation of fact and myth, materiality and poetry, he confronts violence and begins to imagine some hope of salvation.

We do not see the rubble in Kiefer's *Etroits sont les Vaisseaux (Narrow Are the Vessels)* (2002) as static, grounded or passive. Its six tons of concrete and rebar undulates like an ocean wave across gallery or lawn. Its raw and ragged cement, steel and lead evoke the collapsed structures of bombed cities; its movement suggests an aftershock. The title refers to an ode to the sea by the French Nobel Laureate, diplomat and poet pseudonymously known as Saint-John Perse: "In vain the surrounding land traces for us its narrow confines. One same wave throughout the world, one same wave since Troy rolls its haunch toward us." The wave swells, motivated by love and war. Kiefer's wounded, writhing scapes of land or sea embody the incantation from Isa-

iah 45:8: "Let the earth open."[24] From its flailing fissures and seeming death throes, a life force heaves.

Like Szymborska, Kiefer reflects on the dual nature of rubble, as end and beginning:

> Rubble represents not only an end, but also a beginning. In reality, the so-called *Stunde Null* (zero hour) never existed. Rubble is like the blossom of a plant; it is the radiant highpoint of an incessant metabolism, the beginning of a rebirth. And the longer we can put off refilling empty spaces, the more fully and intensively we can produce a past that proceeds with the future as if reflected in a mirror. The *Stunde Null* does not exist. Emptiness bares its opposite within itself.[25]

Other works in OUT OF RUBBLE speak to this refilling of empty spaces.

Jennifer Allora & Guillermo Calzadilla filmed *How To Appear Invisible* (2009) on the site of Berlin's Schlossplatz at the end of 2008 as the Palast der Republik was being demolished. Shown in 2009 at the adjacent Kunsthalle, a temporary structure on this historically significant ground, the video tracks a German Shepherd wandering in the rubble. It wears the kind of protective cone collar that is meant to keep a dog from scratching scabs or licking unhealed wounds. Fashioned from a red and white bucket from the Kentucky Fried Chicken fast-food franchise, its flash of color animates the grey monochrome of rubble and scraped earth. The working machinery and the dog's apparent searching activate the barren stillness.

How To Appear Invisible invites us to consider how spaces emptied by historical events are to be refilled. To erase or preserve the Palast der Republik was much debated. Built in the 1970s, it was central to the public life of the German Democratic Republic as a cultural venue and the parliamentary and legislative seat of the government. It had replaced the former Baroque Hohenzollern palace, the old Stadtschloss. The GDR blew that up in 1950 as it had been heavily damaged by two Allied bombings in 1945 and disdained as a symbol of Prussian imperialism. In 2003, despite protests by those who saw the Palast der Republik as integral to Berlin's culture and the historical process of German reunification, the Bundestag voted to tear it down, leaving the area as park space until funding for new construction was found. In 2007, it voted to build the Stadtschloss facades anew around a modern interior for the Humboldt Forum Project; three years later, construction was postponed as an austerity measure.[26]

Whether animate or inanimate, materials for Allora & Calzadilla are always infused and layered with histories, cultures and politics that are impossible to tease apart. Though the particular rubble in *How To Appear Invisible* it is not a direct result of war and may appear as benign, it starkly reminds us of the succession of seats and structures of power that have fallen and may yet

fall again, in peace or wartime. The falls of the Wall, Honecker and Hitler still haunt Berlin. The latter's favorite canine species, sporting a super-size emblem of capitalism, perhaps embodies a system that considers its own descent—a future in the grim environment of its own making. The recurring rubble from any collapsing system may mark, as Kiefer describes, that "past that proceeds with the future as if reflected in a mirror."[27]

Described as a "connoisseur of ruin," **Julie Mehretu** has also responded to the ghosts of Berlin's past, though those ghosts are certainly nomadic.[28] The destruction wrought by WWII and the ensuing decades of rebuilding and recovery has left a city erased and overwritten, a condition Mehretu captures in recent exacting and dynamic compositions. They suggest the migrating ghosts of cities subjected to abandonment and eradication through empty windows, stranded forms and currents both sinuous and explosive, all in the dominant color of ash.

A residency at Berlin's American Academy engendered works like *Grey Area* and *Atlantic Wall* (both 2009), conjuring spaces in which construction and demolition seem equally immanent, if not already enacted. *Atlantic Wall* refers to Hitler's chain of fortifications that ran from the French coast all the way to Denmark and Norway, and is informed by Paul Virilio's *Bunker Archaeology* (1975), a study of the ruins of these coastal defenses. Working from visual and textual sources concerning war, economic collapse and natural disaster, Mehretu captures the formal and architectural erasures evident in postwar cities such as Berlin and now Baghdad and Kabul.[29] Such erasures are the vestiges of war, but they are never complete or permanent. In *Atlantic Wall*, every step of her painting process remains visible, despite subtractive techniques like sanding and the flurries of abstract marks that threaten, but fail, to obliterate the breathy delicacy beneath them. Each visible layer reminds us of the residue of our own self-destruction, however fragile or tenuous. Erasures in *Grey Area*, however, leave behind vacant patches of gray—little blank spaces of potential. Even after decades of reconstruction, evidence of our violence is preserved and revealed in transitional spaces of cities constantly transformed, from hazy ruins to burgeoning meccas. Like Allora & Calzadilla, Mehretu elaborates on the flux between orientation and disorientation, memory and visibility, presence and absence.

Simon Norfolk writes of European art's fascination with ruins that is not paralleled in other cultures. Images of ruins humble us in facing our own impermanence or induce awe in considering higher powers. Norfolk's photographs induce "awe," but it is more the awe of "shock and awe," the awe of modern warfare that has ravaged Afghanistan for decades. He adopts Mikhail Bakhtin's notion of a "chronotope," a time-space, a place that displays "layeredness" of time.[30] After thirty years of continuous conflict, Afghanistan is

such a place, standing as a Museum of the Archeology of War with Norfolk as its registrar. Abandoned tanks and troop carriers from the Soviet invasion despoil the landscape while other areas are picked clean and swept clear by demining teams. Wounds gape where the USA and UK have bombarded from air. A land altered by bombs is different from one pierced by bullets. Each invader leaves another stratum of tragedy. Ominous black smoke belches in Norfolk's *The brickworks at Hussain Khil, east of Kabul* (2001). In reality, it is a bittersweet indication. Years of massive damage have created soaring demand for new bricks to rebuild.

Seeing the country as a chronotope connects the archeological evidence in the landscape to the story of human disaster, especially when those who have lost their lives leave few, if any, physical traces. *Bullet-scarred outdoor cinema at the Palace of Culture, Karte Char district of Kabul* (2001) reminds us how absurdly distant daily human pleasures become when bombs are raining. The "silver screen" here is silent and sapped of all dreams. It emanates a kind of funerary stillness found in Arnold Böcklin's *Isle of the Dead*, that the painter described as a "a dream picture…[producing] such a stillness that one would be awed by a knock on the door." The dumbness of death has replaced the awe of the sublime.[31]

While Norfolk's chronotopes call for the eye of an archeologist, **Barry Le Va**'s installations call for the eye of a detective. He has compared his works to crime scenes where we puzzle over remains of some past action, whether determined by sudden violence or calm premeditation. Cold logic intersects with mute subjectivity through what Robert Morgan describes as the "artist's purposeful but obscure methodology and by the agonizing complicity of working between a system and a nonsystem."[32] In a moving paean to the artist's project, Morgan asserts: "Le Va's seeming futility of arranging, plotting, distributing, and destroying objects while manipulating synthetic materials disparately across the surface of a temporal ground has suddenly awakened our consciousness to see what is really in front of us, essentially where we are: in the rubble of the present."[33] Furthermore:

> The process of thinking through form, through the psychic dematerialization of space, and through the violence of the political self has overwhelming consequences for the current moment. […] It reifies a particular moment where we are haunted and transfixed by rubble, by the ashes of conflagration, by parts of bodies once loved and now welded down into machinery, melted down into bunkerlike monuments, coffins made for pillaging, and further incarceration and misery for the human race. How can these issues not be felt in relation to Le Va's Wagnerian installations in the present moment? I have to say that all great art is the result of insurmountable conflicts that are somehow confronted—where the imposition of formalist resolutions can

no longer hold sway over the subtle strife of bodies, the tumultuous agony brought on by excessive bartering for power at the cost of losing a sense of the quality of life—maybe, of civilization itself. [34]

Twenty years after Virilio's *Bunker Archeology*, Le Va created *Bunker Coagulation (Pushed from the Right)* (1995) and *From the Rubble: Sorted, Classified, Sealed* (1995). Subsequent writers have also related the haunting, even predictive power of structures left by the wake of war. Touring Suffolk, W.G. Sebald observed, "But the closer I came to these ruins, the more any notion of a mysterious isle of the dead receded, and the more I imagined myself amidst the remains of our own civilization after its extinction in some future catastrophe."[35] In 2006, J.G. Ballard described them as "concrete tombs," architecture "left behind by a race of warrior scientists obsessed with geometry and death."[36] Le Va's hard-edged volumes with neutral slick surfaces initially suggest an affinity with the clean, unembellished geometry of modernism, standing in sterile elegance. Bertolt Brecht explained (without sharing) the utopian yearning for such clarity after the disasters of war: "There's nothing you can say to these sorts that will entice them out of their tiled bathrooms, after they've had to spend a few years of their lives lying around in muddy trenches."[37] Le Va's blind and mute objects embody modernist form but they do not behave as they appear. Order is not obeyed; impervious forms become strangely vulnerable—squeezed, crowded and even huddled.

Suggestive titles often offset the minimalist nature of Le Va's sculptures. *All the Kings Horses, All the Kings Men...* warns of empires falling, and *From the Rubble: Sorted, Classified, Sealed* exudes an especially bureaucratic flavor. The latter evokes the systems of our inhumanity, our disassociation when committing atrocities, our compartmentalization, repression and ultimate dismissal of painful memories. Le Va's blank surfaces and anonymous forms stand as *tabulae rasae*, demonstrating the need or opportunity to start from the beginning.

And we begin being born into families. Amidst the sweep of historical conflict, families uproot, disintegrate or reunite; individuals are lost and found. Victims as well as survivors within these families are portrayed, memorialized or engaged in the works of Helen de Main, Monica Haller, Jennifer Karady and Mary Kelly.

Helen de Main investigates one village and one family—the Arab village of Silwan and the seven members of the Abasi family. Silwan is adjacent to the Old City of Jerusalem, coexisting with the establishment of the "City of David" archeological dig and tourist site.[38] Jewish and Arab residents continue to contest each other's claims and the narratives used to justify possession and dispossession, destruction and construction. De Main's installation *Between Here and Somewhere Else* presents shifting readings of rubble as site of eviction or occupation, ruin or reconstruction.

Human beings share the emotional and physical need to belong to a place. Razing homes denies that need and can destroy the self, family, community and society. The Abasi home was destroyed by the Jerusalem municipality in 2009. With the family's permission, de Main cast rubble from its ruins in bronze for *Silwan Hoard – Abasi Family* (2010). Through a material associated with commemorative medals and monuments, she confers permanence and cultural status on these fragments. They are arranged on seven pedestals that echo the specific heights of the Abasi family members, painted in varying tones of flesh.[39] By insisting on particular colors and exact heights, by preserving the evidence in the most material of ways, de Main counters the erasure of personal and cultural identity as well as the crimes of history.

Mary Kelly's series *Mea Culpa* (1999) presents fragmentary texts drawn from media accounts of documented military atrocities in Cambodia and Sarajevo, Palestine and South Africa. These intensely personal texts of trauma are embossed in soft gray dryer lint collected from washing four thousand pounds of black and white clothing. Evoking the incessant daily labor of women, the banality of lint combines with block lettering to dispassionately spell out a horrific scene between mother and child in Sarajevo: *A few bathroom tiles and the smell of burning. Nothing else left. Probing the ashes she retrieved a family photograph. The faces scratched out with a drill bit. She rocked back and forth on her heels. What will we do? Slit their throats said her four-year-old son.*

The text is based on the true story of an eighteen-month-old Kosovar boy mistakenly left for dead, rescued and re-named by Serbs, later cared for and named again by Albanians, and finally reunited with his parents after the NATO occupation in 1999.[40] Repeated washing cannot alter such stories, cleanse the spilled blood or end the mourning woven into the lives of those never reunited. Lint suggests what is gradually worn down and discarded by the machine, whether domestic appliance or state apparatus. Szymborska speaks to that erosion and erasure: "Those who knew what was going on here must make way for those who know little. And less than little. And finally as little as nothing."[41] Still, judgment awaits. Kelly's *Mea Culpa (Sarajevo, 1992)* (1999) pronounces guilt—*mea culpa*—speaking to what we are left with.

Guilt is more prolonged and more difficult to alleviate among the many emotions that survivors—soldier or civilian—share, along with fear, relief, sorrow and joy. Several artists have developed projects that involve veterans in creating imagery about, for and by the veterans themselves. To make the work, they excavate their emotions that, in turn, become the subject of these projects that reveal, in compelling personal detail, the psychological rubble and recovery that follows tours of duty. They commit memory to word and image, often through processes that entail physical or mental reenactment.

Jennifer Karady has worked with American veterans returning from the

wars in Iraq and Afghanistan to create staged narrative photographs that depict their individual stories and address difficulties in adjusting to civilian life. Intended to be helpful for the veteran subjects, the process of making the photographs is conceptually related to cognitive behavioral therapy. After extensive interviews with veterans and their families, Karady collaborates with them to restage chosen moments from war within the safe space of familiar environments, often surrounded by family and friends.[42]

Soldiers' Stories from Iraq and Afghanistan is a five-year project that dramatizes these chosen moments through both literal depiction and metaphorical and allegorical means. The resulting tableaux, accompanied by recountings of the veterans' experiences in their own words, are poignant, jarring and sometimes surreal. In *Former Sergeant Steve Pyle, US Army, 101st Airborne Division, veteran of the Shock and Awe Invasion of Iraq, with wife Debbie, and children, Steven, Brooke, Cassie, Chloe, Michaela, Mandy, and Brandi, DeLand, FL* (July 2006), a uniformed father assumes a defensive posture in the foreground debris of a demolished structure. His knife is drawn. The backdrop is a family barbecue. What is the threat and what is threatened? In *Former Staff Sergeant Starlyn Lara, C Detachment, 38th Personnel Services Battalion, 1st Infantry Division, U.S. Army, veteran of Operation Iraqi Freedom, Treasure Island, San Francisco, CA* (January 2010), a uniformed woman sits upright in a bed with bundled cash before her, boots ready at the floor. A hole in the wall pierces the charred room around her, revealing a pink bunny that she has chased in her distorted dream.

Cathartic or not, the therapeutic effects derived from creating these works are not necessarily for viewers to share. Haunting, ambiguous images that are carefully constructed over time are encountered instantaneously. The emotional complexity that shapes each reenactment is passed on to the viewer with no deciphering mechanism. We see only a partial but honest glimpse of the confusion of deployment and combat, with no inherent resolution in the psychological palimpsests that emerge, no neat closure.

Veterans Book Project is a library of books that **Monica Haller** collaboratively authors with dozens of people who have been affected by and have archived American wars in Iraq and Afghanistan. In their printed format, the books provide a place or "container" that slows down and materializes the massive number of ephemeral image files that live on veterans' hard drives and in their heads. Haller aims to reactivate and amplify the materials and technologies her collaborators have turned to along the way as a way of processing material artifacts, photographic records and memories both vivid and fading. Each book mines the psychic rubble that sometimes outlasts the physical, often re-deploying volatile images.[43]

Luke Leonard, Iraq (2003) includes a dedication to his grandmother; poet-

ry from Tao Te Ching and Rumi; quotes from the Bhagavad Gita, Ecclesiastes and the Qur'an; accounts of his friendship with Dr. Mohammad and the fall of Saddam; photos of a Kurdish soldier later killed in Baghdad, a boy among goats, a scorpion, and a building in shambles.[44] *Nate Lewis, Iraq* (2003) was created by a veteran who joined the army straight out of high school. September 11, 2001, was his second day of boot camp. His book documents soldiers sparring with orange boxing gloves, GI Joe key chains dangling from rear view mirrors, caravans of camels, detached tank treads, billboards for basmati rice, and a child wearing an adult helmet, standing along a road strewn with rubble. He writes about silencing his own alarms, a mother clawing her face over her dead child and the "rubble, the smoke, the man with the shovel…I visit them in memory so they don't visit me in sleep."[45]

Not all veterans see combat, but many may generate, witness and suffer from the rubble of war. Karady and Haller's projects facilitate reflection, recovery and representation of such experience, melding their own visions and methods with the eyes and voices of those who have been there and come back. Like journalists embedded among soldiers on active duty, artists may embed themselves with soldiers who come home.

SOMEONE HAS TO GET MIRED
IN SCUM AND ASHES,
SOFA SPRINGS,
SPLINTERED GLASS,
AND BLOODY RAGS.

Cornelia Parker addresses the home front through an ordinary garden shed. Sheds are ubiquitous domestic structures that store excess possessions or things no longer needed, they are places of benign refuge.[46] *Cold Dark Matter: An Exploded View* (1991) consists of the charred remains of one. It was assembled, filled with contents from the artist's own shed and those of her friends, illuminated and photographed in the exact location to which it returned— after it had been taken away and blown up by the British Army at the artist's behest. Exploding the shed throws doubt on all it represents, all things safe and familiar. In more ways than one, it brings the war home. Detonated under controlled conditions at a School of Ammunition, the shed's life and death becomes both comical and telling. The army's consent to Parker's request mirrors our own consent, explicit and tacit, to actions carried out by militaries in our name at home and abroad. Might we now imagine what loss of hearth and home might mean to others?

Parker's subsequent suspension of the exploded fragments around a single bulb provided another poignant reversal. Upon seeing the reconstituted de-

bris, the retired major, who molded the plastic explosive in the shape of the original light bulb, became a conscript anew—to the world of contemporary art. Annihilation and creation both come to mind from this cosmos created from a small corner of earth. Cold dark matter emanates from a central source of energy: Is it the "big bang" of atomic weaponry or the origin of the universe? Its shadows remind us, even in an age of information overload and Wikileaks, of how much we still do not know. As in Plato's *Parable of the Cave*, all we can see or know of the real world outside are the shadows flickering within the dark hollow in which we are condemned to live.[47]

Other homes in which we live are condemned to rubble through wars declared and undeclared. **Liu Bolin's** art of concealment initially disguises our dual roles as perpetrators and victims of violence. Despite his ingenious camouflage in *Hiding in the City No. 67 – Artillery* (2007), we recognize that we are collectively one with the canon that fires, one with the bulldozer that wrecks, and one with the rubble that buries. In *Hiding in the City No. 2 – Suo Jai Cun* (2006), Liu paints himself into the urban landscape, a victim of the Chinese government's 2006 demolition of the Suo Jai Cun artists' neighborhood in Beijing. Though not an act of war in the military sense, the village was razed by state force, under the pretext of redevelopment for the 2008 Olympic Games. Liu and others were left homeless, disrupted by a government wary of artists living and working together as it focuses on its growing modern and commercial image.[48] Countering the speed of change that wipes out the old to make way for the new, Liu assumes frozen poses that last up to ten hours. This stasis is paradoxical. On the one hand, it reflects the passivity of citizens who hide and adapt to forced changes. On the other, these stationary subjects stand in silent protest against the state and its actions.

While Liu captures himself standing in rubble, **Osman Khan** captures the viewer standing under it. An imposing monitor hangs above viewers' heads in the installation *The destruction of the house of Abu al-Aish*. The audience experiences both an actual physical threat (of a falling monitor) and a represented threat (displayed on the screen). Generated by a software program, animated geometric fragments create a perpetual and virtual rain of debris, as if plummeting from a bombed roof or dark sky. Rendered to lose any specificity, these fragments might be from any war. By abstracting and aestheticizing the incident, Khan reminds us of mass media's treatment of such imagery, the horrors that play over again and again until the television sets are turned off and a new news cycle begins.

Still, the house and family destroyed is far from abstract. It was the home of Dr. Ezzeldeen Abu al-Aish that sheltered eighteen people during Israel's 2009 bombardment of the Gaza Strip. It was his family that was destroyed when his three daughters were killed. The Israeli trained doctor and peace

activist had been involved in promoting joint Israeli-Palestinian projects. He was subsequently nominated in 2009 for the Nobel Peace Prize and is the recent author of *I Shall Not Hate*.[49] He is also an academic who, before leaving Israel, studied the effects of war on Gazan and Israeli children.

Andrew Ellis Johnson's *Formal Graffiti* (2011), a series of manipulated photographs, also speaks to these effects. School during wartime is interrupted if not impossible; nevertheless, children learn lessons that devastation delivers. With this in mind, the artist photographed the Children's Hospital in Pittsburgh as it was being torn down in 2010, creating and criticizing equivalences between an American hospital demolished for peaceful purposes and those destroyed by militaries abroad. US coalition forces have bombed Iraqi hospitals in Baghdad, Nasriya and Rutbah, and the al Quds, al Fata and al Wafa hospitals in Gaza were shelled in Israel's Operation Cast Lead in 2008-09.[50]

As in Khan's video, the rubble in *Formal Graffiti* could be from almost anywhere. Certain details, however, like the ripped pink insulation in *Ha' (ou Kha' ou Djim)* (2011), suggest a particular climate that needs it; it is now a useless barrier against discomfort, fleshy against grit and shard. Decorative remnants of nursery wallpaper reveal function and clientele, attesting to the youth that the building once served and healed. They stand in stark contrast to dangling chunks of cement and rebar and mounds of raw debris that echo lives crushed or hanging by a thread—elsewhere.

Diagrams from a lesson book for Arabic handwriting, with outlines for filling in and guiding grids for proper proportions, are superimposed on top of Johnson's images of ruin. Mangled pipes and metal are digitally manipulated to become calligraphic letters, as in *Lam, Miim, Noun, Ha' et La': I* (2011), intertwining the spaces of the picture plane and the wreckage behind it. These letters (not words) become the ABC's of destruction. "This alphabet, preceding meaning, is elemental and foundational, representing the fundamental education our actions teach."[51]

Letters and their absence offer less concrete lessons in *Where Does the Dust Collect?* (2004), an installation by **Xu Bing** that examines what truth might mean among conflicting perspectives. The material he uses is transformed and transforming, from catastrophic conditions to states of innocence and perhaps enlightenment. The artist cast ashen residue collected from the streets of lower Manhattan — the pulverized aftermath of September 11, 2001 — into the form of a doll. In this solid state, the potentially toxic material is transported and deconstituted into meditative environments around the world. The ingredients of the doll are ground in a coffee grinder, blown into a gallery space with a leaf blower and left to settle over a passage of stenciled poetry by Hui-neng (638-713), traditionally considered to be the Sixth Patriarch of Zen Buddhism in China.

Hui-neng questions the teachings of his predecessor who claimed to understand the faith in all its purity, whose poetry is declarative rather than inquisitive:

The body is the Bodhi tree;
The soul is like the mirror bright,
Take heed to keep it always clean,
And let no dust collect upon it.

Hui-neng cannot see the bright mirror, the pure soul, and therefore neither sees how the dust can settle upon it nor how the soul becomes impure. Moral certainty and true wisdom, as represented by the Bodhi tree, remain elusive:

The Bodhi (True Wisdom) is not like the tree;
The mirror bright is nowhere shining;
As there is nothing from the first,
Where does the dust itself collect?

The last line of this stanza becomes visible in Xu Bing's field of dust; its letters are the only shapes and spaces left untouched and unsullied by the residue of our violence. From the most horrific to the most delicate of deliveries, Xu Bing's gathered and dispersed rubble invites us to trade certainty for doubt, to question our rigid oppositions and their consequences.[52]

The chasm created by those consequences, and between their perception and reality, motivates the work of **Adel Abidin**. For the installation *Construction Site* (2005), Abidin videotaped a scene from a Baghdad street after an explosion, immersing us in a child's world amid random violence.[53] Viewers must crouch down before actual rubble in front of and at the feet of the girl in the video to watch the intensity and insularity of her play. Wearing pink plastic sandals, she innocently sings an Iraqi children's song about peace while moving bits of debris with two plastic spoons—perhaps her only way of coping.[54] There is no doll in sight to enact her fantasies or dreams. In a situation too terrible to express, preserving sanity may only be possible through such tiny acts of the imagination.

Countering the Western media's representation of Iraq and Iraqis, Abidin reveals the abyss between what is communicated about recent life in Baghdad and what cannot be communicated—the anguish of how war is *lived*. The pathos of *Construction Site* takes on sarcasm, irony and humor in subsequent works that address war and exile, nationalism and cultural identity, terror and heroism in the wake of the 2003 US invasion of Iraq. In *Abidin's Travels*, a fake travel agency promotes vacation trips to Baghdad, through videos, posters, light boxes, tourist guide brochures and a ticket booking facility. Expectations of destination highlights soon give way to graphic images of death and

devastation as the tacky hard sell reveals that all "the beautiful places that you might have read about are either destroyed or have been looted. There really are no sights left."[55]

In a similar tactic, **Taysir Batniji** created a mock real estate agency offering homes in Gaza. An exile in Paris, Batniji worked for nearly two years with a Palestinian photographer who was able to capture "rooms with a view" in thirty-three residential properties damaged during the Gaza War of 2008-09 (code-named by the Israeli government as Operation Cast Lead).[56] The resulting work, *GH0809*, transforms these views into real estate ads with copy that belies the accompanying images of overturned furniture, holes in walls and heaps of rubble on cool marble floors. The factual and statistical language describing the property ignores the political realities that nullify its selling features. Batniji blends dark humor and irony to reveal the common dream of a home as refuge and its impossibility in this part of the world, despite the lure of fountains and garages, fig and olive orchards, sunny weather and unrestricted ocean views. Proximity to beach *and* Al Shati refugee camp mocks the real estate mantra of "location, location." This premium, like many other criteria determining domestic and commercial value, is sabotaged by war.

PHOTOGENIC IT'S NOT,
AND TAKES YEARS.
ALL THE CAMERAS HAVE LEFT
FOR ANOTHER WAR.

Those surviving rubble need no documentation to know the loss it represents and the long haul of rebuilding. For those living in intact environments, photography can bear only partial witness to the blows of war, offering images and narratives that tell only part of the story, leaving us at the threshold of experience beyond our comprehension. The whole picture—the whole story— would be too much to bear, too depressing, too revealing of our complicity and consent. Better to be blind, to acquiesce to amnesia, to find asylum in entertainment.

Photography serves both the most blatant infotainment and the most searing of exposés. The lens can dwell with compassion and concern or distort with cynicism and sensationalism; sometimes it is difficult to tell the difference. The spectacle of suffering can activate public and private rescue responses that are often all too fleeting and superficial. Representations of media rarely cultivate structural solutions for the problems that cause or follow war. Our sympathies are easily misguided or out of focus, exhausted or fickle, distracted by and rushing to the novelty of the next tragedy.

Artists, too, struggle with the power of representation and the limits of

that power. They use and deliberately abuse documentary and media tactics for their own varied purposes. **Raquel Maulwurf** and **Elaine Spatz-Rabinowitz** draw from the photographic record to speak to the continuity of war, the consistency and physicality of its consequences. Maulwurf depicts scenes of rubble distant and recent and across continents. Most precede her time and are thus reliant on photographic sources. Spanning WWII targets to Ground Zero of 2001, she creates a portraiture of war's ruins. Separate drawings portray cities like Warsaw, Cologne, Berlin and Hiroshima, but the skeletal remains of *Dresden Sidonienstrasse* (2009) are all too similar to those of *New York 11 IX '01* (2006). Spatz-Rabinowitz also speaks to the ubiquity and sameness of war's tragedy, layering her photographic references across a timeline of conflict. In *Iraqi Ditch*, she evokes countless assaults on the innocent, juxtaposing imagery of small blue slippers from Afghanistan with dolls from Auschwitz. Collateral damage from an arid Middle East merges with that of tropical Vietnam.[57] Hers is a collective portrait of what war wreaks, unified and meticulously painted on monolithic slabs of plaster.

Maulwurf and Spatz-Rabinowitz materialize destruction in both subject and process. In *Luftangriff Berlin April '45* and *Fliegerangriff auf Berlin April '45* (both 2008), Maulwurf's pastel and charcoal become rising smoke and settling ash, charred structures and searing flames, frail armatures stripped of their identities and collapsed into smoldering piles. Drawing on thicker board allows her to brutalize the surface with abrasive and subtractive processes, to a degree reenacting the violence. Raw patches in the plaster finish of Spatz-Rabinowitz's *Near the Airport, Beirut, July 2006* (2006) extend the smoke billowing from a burning car; the surface's distressed greasy blackness seems to reek of oil fumes. She uses Hydrocal, embedded with pigments, charcoal markings and old plaster patinas from prior pours, to create rough cast substrates born partly of chance and accident. They become fields for incidents of arbitrary and deliberate violence, culled from her vast collection of photojournalistic images that catalogue dispute turned to debacle. The single image captured by a lens is expanded with fragments from multiple realities.[58] While dependent on photographic sources, both Maulwurf and Spatz-Rabinowitz transcend them. Their materials do what the smooth and uniform surfaces of photography cannot. They make the damage tactile; they give it weight.

Weight dissolves in the elegiac watercolors of **Pamela Wilson-Ryckman**. Their delicacy verges on subverting the dire nature of the scenes that wash over us in the daily flood of media images. In works like *Corner (left)*, and *Corner (right)* (both 2007), Kenneth Baker identifies, "a tension between assertive technique and realities that elude mediation altogether."[59] White shapes of exposed paper become ghosts of objects flung randomly by explosive force. They hover above a ground of stained and milky grays, quietly emphasizing windows blown

out of their frames, things that were once whole. The soft sensuality of water-color stands in poignant contrast to the glaring light that reveals subjects without mercy: car bombs, explosions, wreckage, floods and mass violence. At first glance, transparency, pale palettes and lightness of touch might fool us. They might temper the turmoil and calm the chaos. They might transform these crises into mirages not of this world, but the horror of shock and awe is not humbled.

Conditions of weight and gravity, literally and figuratively, are also in question in the work of **Curtis Mann**. Hulks and fragments of buildings balance precariously or freeze in mid-air. It is unclear whether they are exploding upward, raining down or levitating in perpetuity. Pastel skies belie the ruin below in *Building, Standing (Beirut)* (2008) and dense cinderblock walls float above the absence of any solid ground in *remains of a home (incursion)* (2007). Instead, a trapezoid of red vapor frames whatever is left, a carpet with no trace of magic, trod upon by one lone man. Curiously, the predominantly white fields and blankness of these two landscapes resist identification with specific nations or conflicts, titles notwithstanding.

Starting with prints of images found on photo-sharing sites, Mann then coats them unevenly with varnish. He subsequently subjects them to bleach that fades or erases any area unprotected by the varnish. This defacing process echoes the eradication of peoples and places besieged by war. The process and its fluid traces also makes the malleability of images transparent, challenging photography's reliability as a documentary tool and its inability to provide complete contexts or truths. He takes us beyond the found images' initial purpose, using the very materials, chemicals and inks responsible for their creation to undo their veracity and cohesion.[60]

While Mann's images almost seem to wash away, **Enrique Castrejon** pins his down. Using a neutral palette and modest materials of cut paper, tape and tacks, he creates explosive wall installations and collages like *Wasteland: Najaf* (2005). Ironically, the pandemonium of events depicted is actually determined by geometric calculations. Castrejon bases his images on those he finds in architectural drawings, newspapers or news magazines, rebuilding them through a laborious mapping and transcription of specific shapes and forms. Measurements are annotated on fragments of found paper and reassembled with hundreds of pins and tape.[61] The physical presence of the resulting drawing hangs as an elaborate monochromatic collage that seems entirely provisional and impermanent, approaching the point of collapse that has already occurred in each scene of our crimes against humanity. Breaking down visual representation and meaning is perhaps the only appropriate response to senseless violence. The analytical nature of the process becomes almost absurd in its unsettling balance of disintegration and reintegration. It can find no rhyme or reason. It cannot patch back together or resurrect.

Many of the artists in OUT OF RUBBLE confront and critique mediated images that are central to their projects, considering their contexts and the nature of their impact. **Thomas Ruff** explores the distribution and reception of images in the digital age and interrogates the grammar of media. Choosing the computer over the camera and the web over the world, Ruff manipulates JPEGs (the standard compression files for digital images) of images ranging from the idyllic to the catastrophic. The latter include a Beirut building reduced to rubble by Israeli missiles, a teetering shell of the World Trade Center facade and the bombing of Baghdad. By enlarging thumbnail images to C-prints with Diasec that approach ten feet in height, the images are radically transformed. From afar, they become the somber spectacles of media saturation. With closer inspection, the geometric seams of JPEG compression reduce these familiar images to rectilinear clusters of different tones. Even closer, the pictures break down into abstract fields of pixilation, into grids that can also act as barriers. This degeneration of the image parallels the disintegration of the structures depicted; both resist recognition. It is skeptical of the truthfulness of photography—its capacity to capture only the skin of reality. We cannot experience the depth of damage or fathom the deception that distance enables when facing works like *jpeg ny05* (2004) or *jpeg bu02* (2004). The degree of our physical and emotional distance fluctuates, depending literally on where we stand and on our mode of reception, but that distance never fully dissolves. We can never get past the surface.

Christoph Draeger creates interlocking surfaces in his ongoing series *The most beautiful disasters in the world.* From the flood of media images, consumed at an ever-accelerating rate and canceling each other out through profusion and redundancy, Draeger carefully chooses subjects to turn into icons. Like Ruff, he digitally reprocesses the images, enlarging and transferring them onto large-format puzzles of up to 8000 pieces.[62] Jigsaw puzzles are usually associated with idyllic or picturesque scenes and require a slow but leisurely process of reassembly that resists cursory attention. They counter the quick consumption of endless cycles of fleeting media sensations. They fix our focus on how and why we react (or fail to react) to this disaster or the next.

As a pleasant and mostly mindless pastime, puzzles often disengage seeing from the content of what is seen. The quiet and patient analysis involved belies the intensity of the crises Draeger chooses to revisit. Effective surgeons must remain emotionally neutral from the injuries they repair. Draeger ushers us toward such objectivity, to questioning our own perceptions and reactions to the mediation of trauma. Unlike those who must cope with real ruins, we are lost in a benign process of putting the pieces together, becoming or remaining inured to the image (and reality) of rubble. We question whether our responses are manufactured, genuine or natural, clinical or compassionate. In

further complication, works like *Ground Zero, New York, Sep 11 2001 (Coca Cola)* (2003) and *Nagasaki, Aug 9 1945* (2008) create a paradox of constructing destruction. We may be disposed to see an endless cycle of violence or a compelling exercise of symbolic reconstruction.

Destruction is reconstructed, catalogued, invented and "made flesh" in works by Wafaa Bilal, Samina Mansuri and Walid Raad. **Wafaa Bilal** resists surgical neutrality as a strategy; his own brother, Haj, was killed by a Predator drone attack in Al Kufa, Iraq, and his father died weeks later of grief.[63] Bilal photographs material that is literally visceral in *The Ashes Series* (2009). For these archival inkjet prints, he fashions miniature sets based on media photographs of domestic interiors destroyed during the war in Iraq. They include a bombed mosque, a hospital room with a single bed and a room from Saddam Hussein's palace with one ornate Louis XIV chair left standing amid the former luxury. These tiny constructed tableaux close the distance from their sources in media photographs with the residue of real flesh. Twenty-one grams of human ashes are sifted with other organic cinders, photographed, blown up and printed in large format, rendering scale ambiguous and disorienting.[64] This measurement of ashes connects with the 2003 film *21 Grams* by Alejandro González Iñárritu. Its title refers to the belief promulgated by the discredited 1907 research of Dr. Duncan MacDougall in his efforts to prove the existence of the human soul. He determined that, at death, the body lost twenty-one grams of weight with the soul's departure.[65] Bilal's invoking of "body and soul" reinforces the subjective in face of journalism's claim to objectivity and the human costs in face of terms like "collateral damage."

Samina Mansuri also manufactures models and images of places that seem still smoldering. Adopting and transforming media strategies, she documents an invented devastation through physical and virtual constructions that hover between credibility and fantasy. Works like *Digar (04)*, *Digar (17)*, *Olara (12)*, *Sidadarae (10)* and *Olaraaee* (all 2008) from the *ASH Archive* arise from media depictions of places (like Afghanistan, Iraq and Pakistan) that are frequently represented as shattered and pulverized to nothing but ash and rubble. Mansuri assumes the aerial perspective that is so prevalent (and so detaching) in news media, but, like Bilal, resists that detachment. Through her constructed fictional sites and altered histories, she creates "subjective mappings of an ambiguous location of trauma." In doing so, she calls attention to our consumption of mediated representations of misery and their impact on individual and public memory.[66]

The device of the fictional archive is central to the work of **Walid Raad** as well. Under the collective guise of the Atlas Group, an imaginary research foundation based in New York and Beirut, he purportedly chronicled the contemporary history of his native Lebanon during its civil war of 1975-90 through

unattributed sources and questionable documents, as if winking at his audience. Raad's narratives and fabricated documents are vague in their veracity, "fantasies erected from the material of collective memories," but their darkly comic absurdity conveys the tragedy of larger historical truths.[67] His manipulation reiterates the degree of subjectivity and contested nature of historical memory.

Though solely attributed to Raad, a later series, *Let's Be Honest, the Weather Helped (Finland, Germany, Greece, Egypt, Belgium)* (1984-2007), continues to blend fact and fiction. Black and white photographs of Beirut are overlaid with colorful dots that initially read as playful graphics. In fact, they cover holes created by bombs and bullets in walls throughout the city. These seemingly benign spots function as an indicting code. The text that accompanies the series of seventeen inkjet prints explains how the artist collected used shells embedded in Beirut buildings in the early 1980s—each with their own colored tips—and catalogued their locations in his notebooks. Upon discovering that arms manufacturers color code their munitions, this cataloging acquired new meaning.[68] It became an inventory of the seventeen countries that supplied arms to Lebanon's warring factions, a document of international complicity. The cool aesthetic delivery of this damning information delays but does not diminish its wallop.

AFTER EVERY WAR
SOMEONE HAS TO CLEAN UP.
THINGS WON'T
STRAIGHTEN THEMSELVES UP, AFTER ALL.

Responding to more recent conflict (between Israel and Hezbollah) in Lebanon, Beirut-based **IDEA sarl** consultants, Nachaat Ouayda and Sami Markus, developed *Project R (Rubble House)* (2008). After Israel's thirty-four-day bombing campaign in 2006, countless houses in southern Lebanon were left in rubble. The architectural concept of *Project R* arose from dire environmental, socioeconomic and logistical needs in rural areas: replacing housing in villages targeted by air raids, repairing destroyed infrastructure, removing and disposing rubble, and transporting raw material for reconstruction. *Project R* involves trapping rubble within wire mesh cages, transforming modular gabions normally used for retaining walls as a structural element in a simple architectural system. With this system, single-story, multi-use structures can be built within three weeks, at a fraction of the cost of prefabricated houses, with minimal raw material, training and equipment.

The arbitrary cruelty of war against civilians can render its victims powerless. *Project R* ameliorates this condition as it employs the local community in rebuilding itself and reduces its dependency on heavy machinery, scarce

concrete, special expertise and external aid. Eliminating the need to move and dump rubble via destroyed roads and infrastructure, the system maximizes the use of rubble in place as raw construction material. It provides versatile functionality necessary for comprehensive community recovery. Though designed for temporary relief, the structures are durable and protect from the elements. They exemplify green and sustainable design before, during and after primary uses as schools, clinics or communal spaces as they can be dismantled later to rehabilitate old quarries, shore up riverbanks or be used for retaining walls and bridge embankments.[69]

Through creative and compassionate pragmatism, ruins transform into "rubble with a cause." Apart from their original impetus, the consultants also found their concept relevant for the extensive destruction of the Nahr al-Bared Palestinian refugee camp that was caught in the 2007 conflict between the Lebanese Army and Fatah al-Islam militants. To facilitate open access, immediate implementation and cost-effectiveness for its users in and outside of Lebanon, Ouayda and Markus purposely did not patent their design before its publication in August that year.[70] Modified versions of the gabion structure in *Project R* have since been built in areas badly affected by the 2010 earthquake in Haiti like those by Oxfam in Lilavois and the Haiti Replacement Homes Project in Grand Goave and Croix-de-Bouquets.[71]

The collective **Decolonizing Architecture** also repurposes rubble, using spatial practice as a form of political intervention and narration. They observe that the "acceptable precondition for planning is a situation of spatial and political certainty—a clear site demarcation, a schedule, a client and a budget. The erratic nature of Israeli control and the unpredictable military and political developments on the ground renders Palestine an environment of high uncertainty and indeterminacy. Planning in such conditions could not appeal to any tested professional methods."[72]

Decolonizing Architecture responds to the uncertainty and indeterminacy of sites like Oush Grab, a former Israeli military base that has been cannibalized for construction materials and reshaped as both a source for landfill and a dumping ground for unwanted rubble. *Project: Return to Nature* (in progress) proposes the transformation of this site. It would render its buildings unusable to prevent "revolving door occupation" by drilling holes in the walls to create concrete screens and shifting the ramparts to partially bury the buildings in the rubble of their own fortifications. These alterations would make the site hospitable to migrating birds converging over Palestine that tend to land on the Oush Grab hilltop. Decolonizing Architecture's proposed reuse of this site becomes an intervention in the political struggle for this "closed military zone" claimed by Israeli settler groups and Palestinian and international activists alike, providing roost for birds who know no borders.[73]

While architects and consultants use rubble for reconstruction and resistance in the physical world, artists like **Lenka Clayton** rebuild with it in a way that crosses from the actual to the imaginary. In *Repairing Lebanon* (2007), she digitally alters five images of buildings damaged during the 2006 conflict with Israel. A journalist working in Lebanon took the source images specifically for this project. Clayton asked for no information about the original buildings and had no idea how they had looked before bombardment. Close examination of the ruins within the photograph provided the only clues for envisioning their prior status and for visually repairing each edifice. All tones and textures were limited to the information available within the original image.[74]

Clayton is careful to retain the artifice and uncertainty of her repair. In comparing "before" and "after" images, the reconstituted structures can appear slightly askew, with cutout qualities suggesting the scrims of temporary stage sets rather than architectural solidity. Like Decolonizing Architecture, she responds to the uncertainty of war and its consequences. Even with postwar recovery, things are *not* like they were before. Despite the healing power of the human imagination, the fissures and frailty of our built environments and psyches are neither disguised nor erased.

We'll need the bridges back,
and new railway stations.
Sleeves will go ragged
from rolling them up.

The work of **Jane Dixon**, elin o'Hara slavick and Susanne Slavick encompasses loss and survival, acknowledging disappearance while imagining replacement. Jane Dixon's *Regeneration* project (2005-2010) consists of drawings, paintings and prints arising from her visits to cities destroyed by war and disasters of nature and subsequently rebuilt. Through images of Berlin, Chicago, Tokyo and Yokohama, with a final cycle referring to the London Blitz, she investigates absence and presence, the lost and found, impermanence and "the restructuring of our occupied space, both real and through memory."

Materials, process and image are equally integral to the meaning of Dixon's work. Her methods for *Regeneration* are akin to those of archaeology and forensic science. Like Simon Norfolk, she is drawn to the analysis of the past through exposed layers or methodological revelation of surfaces, treating her works as "urban palimpsests or artificial excavations."

Regeneration III (Yokohama) (2006) is one of four etchings generated from the artist's photographs of specific cityscapes. Here, she magnifies the discrepancy between illusory and real dimensionality, creating a dialogue between digital and analogue processes. *Tokyo 2* (2008) is one of three paintings made of lay-

ers of rubbings on specially constructed material. The rubbings are taken from both existing buildings and relief surfaces of paintings made specifically for the *Regeneration* project and subsequently discarded, conceptually echoing what perishes in war and what lives on. The painting's final state incorporates layers both real and manufactured, paralleling "the factual and the filtered imagery of memory." Paradoxically, the physicality of her work speaks to the ephemeral, creating ghostly transitional fields that balance negation and potential, the precarious and the sustainable. In reflecting on the past and anticipating a possible changed future, Dixon creates "blueprints for the unknown."[75]

elin o'Hara slavick is also concerned with assaulted cities, recording in *Bomb After Bomb: A Violent Cartography* (2007) forty-seven places that the USA has bombed.[76] In a subsequent project, *Hiroshima: After Aftermath*, she examines what lingers and endures in one bombed city decades after its destruction.[77] Subjecting x-ray film and paper to radiation, the sun and the surfaces of survival, slavick collects and creates blank shadows, textured traces and ghostly emanations from the most notorious atomic blast site—Hiroshima.

Koko Bridge Reconstructed (2009) consists of five silver-gelatin contact prints from a single frottage made by rubbing the rough cement wall of the actual pedestrian structure. The Koko Bridge withstood the bombing of its location at Hiroshima's Shukkeien Garden, surrounded by the most profound rubble of our time. Spanning twenty-five feet, this array of prints flattens the dimensional, dissects the intact and reassembles the pieces, echoing the history and transformation of the larger city. Its ghostly imprint arches symbolically between past and present.

Tree Stump (2008) is another silver-gelatin contact print made from an autoradiograph of something less whole: an A-bombed tree fragment from the Hiroshima Peace Memorial Museum Archive. Placed on a sheet of x-ray film in light-tight conditions for ten days, the resulting spectral image suggests persistent radiation, even if minute. In her essay *Hiroshima: A Visual Record*, the artist states that the history of the atomic age is intertwined with that of photography.[78] In exposing objects chemically, manually and metaphorically, she insists on the currency and urgency of continuing nuclear threats resulting from war, theories of deterrence and seismic events. Invoking both the destructive and constructive power of light, she merges abstraction with reality.

Destruction, reconstruction, death and rebirth permeate the imagery of this essay's author, **Susanne Slavick**.[79] Rebuilt bridges and trees of life abound in the *R&R(&R)* series (2006-2008) among other restorations of destroyed nature and infrastructure. The project converts the military abbreviation for "rest and relaxation" to words like "rue, regenerate and resurrect." It borrows and builds images from the art and architecture of the invader and the invaded, often choosing details that metaphorically restore "a wholeness, whether

prosaic or paradisiacal, that has been lost in the devastation depicted."[80]

Scenes of construction and cultivation, particularly from the workshops of Persian miniaturist Bihzâd and the court arts of Safavid Iran, are painted over prints of digitally manipulated photographs of wreckage across the former Islamic Empire—in Afghanistan, Iraq, Lebanon and Pakistan. Altering these images by hand is an attempt at empathic unsettlement and restitution, at replacing the anonymous, ashen monochrome of rubble.[81] Gestures at undoing the damage begin to supplant, if only visually, what has been lost while reminding us of what is still being eradicated.

Restoration (Threshold I) (2006) inserts transparent white tracery of mashrabiyas (the ornate wooden latticework prevalent in traditional Arab architecture dating to twelfth-century Baghdad) amid the 2006 ruins of Khiyam, Lebanon.[82] *Resilience II* (2008) superimposes the pattern of a stone screen from the sixteenth-century tomb of Muhammad Ghaus in Gwalior, India, over an altered image of one of Saddam Hussein's destroyed palaces found on a photo-sharing website. These ornamental motifs are embedded to insist that the targets of war are neither faceless enemies nor sites devoid of culture. They are not just *anywhere* but *somewhere,* not just *anyone* but *someone*—the "someone" rolling sleeves up to bury or begin anew.

IN THE GRASS THAT HAS OVERGROWN
CAUSES AND EFFECTS,
SOMEONE MUST BE STRETCHED OUT
BLADE OF GRASS IN HIS MOUTH
GAZING AT THE CLOUDS.

Losing oneself in the sky can induce regret as much as reverie. Knowing the beauty of heaven over the desert, **Rocío Rodríguez** looks up one evening outside her studio in Atlanta, thinking "somewhere out there in that desert are rotting bodies under a beautiful night sky like this."[83] Plunging through the "grass that has overgrown causes and effects," she does not stretch out to relax or forget. Instead, Rodríguez imagines the forces that explode and unravel the structures and routines of lives in countryside and city during wartime. In *Baghdad, The Round City* (2007), she maps a city losing coherence, no longer whole. Abstracted networks of roads, beams and veins tangle up with colors of flesh and earth in a maelstrom of raw vulnerability. *Crush* (2009) captures a furious and more immediate aggressive force slamming into or flying out of a cluster of structures. Community is decimated. Conscious of her own distance from such horrors, these large paintings attempt to resist the numbness, amnesia and other defenses that develop even after willful and frequent exposure to the documentation of war.

MadeIn Company, an artists' collective founded in 2009 by Xu Zhen, brings the sky to earth in *The Colour of Heaven* (2009). (The group's moniker also phonetically translates to "without a roof" in Chinese.)[84] The installation is a sea of overturned glasses reminiscent of specimen domes; they entrap tiny painted scenes of conflagration, mushroom clouds from atomic bomb explosions. Deceptive in their fragile transparency, perhaps the domes protect us from the harmful effects of radiation. Sealed off, perhaps they deprive the fire of the air that is necessary to burn and that is essential to life on earth.

In another installation, MadeIn uses air to override the typical equation of rubble with mortality. Flattened fields of debris usually signify annihilation and eradication, a house, village or city wiped out, graves unmarked. *Calm* (2009) is a bed of such rubble that initially appears still and lifeless. Expectations shift as the fragments subtly heave and resettle as if in shallow breathing. Positioned on top of a motorized water mattress, the sculpture undulates in soft waves. Though "there is no calmness after the bomb," survival lies within this strange aftershock.[85]

Both *The Colour of Heaven* and *Calm* were made for *Seeing One's Own Eyes*, a kind of exhibition in disguise—"an exhibition of an exhibition." Its title refers to the Qur'anic verse: "My way, and that of my followers, is to call you to God, on evidence as clear as seeing with one's own eyes" (Sura 12, verse 108).[86] Impersonating a group of fictional Middle Eastern artists, MadeIn, as agency, curator and artist, challenges clichéd perceptions and expectations of the region as fueled solely by oil production and beset with religious strife. Like Xu Bing's poetically inspired *Where Does the Dust Collect?*, the work of MadeIn Company is an appeal for critical refection, to consider *how* we see as much as *what* we see.[87]

From the ruins of our own making, what *can* we see? Looking at, into and through **Diana Al-Hadid**'s baroque architectural forms, we are easily transported. Works like *The Tower of Infinite Problems* and *The Problem of Infinite Towers* (both 2008) blend labyrinthine towers with industrial tubes and pipe organs that verge on the mechanical. These and other fantastic edifices hover between generation and deterioration, surrendering to the elements or the violence of current upheavals. They become portals between distant legend and immediate realities, superstition and science, dynamic flux and tense arrest. Many appear charred, melted, distressed, toppled or in various stages of ruin.

Built from Our Tallest Tales (2008) combines Al-Hadid's opposing instincts: the one that organizes with mathematical precision and planning and the one that improvises with recklessness.[88] Embedded within its mass of honeycomb rubble, we see motifs from Islamic design and mimicry of the architecture of nature itself, albeit in collapse. Informed by Eastern and Western influences, including ancient Biblical and mythological narratives from *A Thousand and*

One Nights to Ariadne, Arabic oral traditions and Gothic architecture, iconic Western painting and Islamic ornamentation, and advances in physics and astronomy, she links the fabled construction of the Tower of Babel with the construction of European medieval churches and the 9-11 collapse of the World Trade Towers. Milan Kundera, the Czech author of *The Unbearable Lightness of Being* (a title that would suit some of Al-Hadid's work), might be dubious or admiring of such scope, as he asserted in a 2007 essay: "Art isn't there to be some great mirror registering all of History's ups and downs, variations, endless repetitions. Art is not a village band marching dutifully along at History's heels. It is there to create it's own history."[89] Still, from the destruction and decay in Al-Hadid's work, we infer an almost encyclopedic survey of human history, a "record of a mortal universe."[90]

Armita Raafat works with equally monumental structures but in forms even more fragmented. She marries structures, patterns and motifs of Islamic and Persian architecture with papier-mâché and plaster, styrene, cardboard, and bits of Persian fabrics, laced throughout with charcoal, indigo and turquoise hues.[91] Subjected to additive and subtractive processes, her ornamental components also exist in a state of ruin, often mounted along the perimeter of a site. They spread like brittle webs, creeping and crumbling from corner to floor. Inspired by a seventeenth-century architectural masterpiece of the Safavid Empire, the Sheikh Lotfollah Mosque in Isfahan, Iran, Raafat's untitled 2008 and 2009 site-specific installations incorporate fragments of *muqarnas,* an architectural motif comprised of three-dimensional decorative niche elements arranged in tiers.[92] Their distortion and fragmentation remind us of something once complete, a mosque's sense of harmony and perfection. By simulating damage or disrepair, she alludes to the pervasive destruction that resulted from the Iran-Iraq War (1980-88) and the fragility of life in Iran today—from continued conflict in the region to ongoing tensions between Iran and the United States. She subtly stages sites that are re-created, re-obliterated, re-revealed and re-destroyed.

The modular nature of webs and honeycombs echoes that of ornamentation prevalent throughout Middle Eastern culture—in tiles, textiles, calligraphy, wood lattices, stone screens and architectural reliefs. This ornamentation is not just limited to surface, however; it informs structure as well and is a universe unto itself. The bee in the hive works for the entire colony; pattern synthesizes disparate parts into a unified whole. The use of pattern is metaphorical and more for both Al-Hadid and Raafat. While Al-Hadid fills some of her hexagonal honeycomb cells with color to resemble mosaic, Raafat fills some of her warped geometry with mirrors that disorient with their odd angles. Musing on our aspirations and failures, our bloodlust or our quest for survival, the tiny reflections they offer pronounce us either the fairest or the ugliest of all.

Fairy tales and myths build on and perpetuate ancient archetypes, recurring fantasies and the persistent moral quandaries of humanity. When vision and interpretation are acute and probing, the realm of the imagination can compound our despair; however, those same capacities can see beyond the present, rescuing us from despair and thwarting the death wish the human race often enacts. Creative making does not undo injustice, pain or the wreckage of mind and matter, but it helps us persist.

Lida Abdul explores the shifting memory of trauma—and our continued attempts and failures to move past that memory. Abdul's work questions how we face nothing and emptiness where something once was. She paraphrases Maurice Blanchot: "A disaster touches nothing but changes everything. Afghanistan is physically destroyed, yes, but the resilience to survive persists unabated."[93] In trying to comprehend the ravages of her native Afghanistan for more than two decades, one of the ways Abdul proceeds is by juxtaposing "the space of politics with the space of reverie."[94] A series of short performance-based videos staged among the ruins of her homeland include children who, for pay or pleasure, respond with ingenuity to the lunacy of war. In *Bricksellers of Kabul* (2006), they sell bricks in the desert, possibly from pillaged homes, to be used for rebuilding the obliterated.[95] *In Transit* (2006) shows nearly sixty children converting the debris of war from a downed Russian plane and turning it into objects for survival and play. For Abdul, such transformations and imaginative acts signal hope amid devastation.

In *White House* (2005), Abdul whitewashes the ruins of a former presidential palace on the outskirts of Kabul for three days.[96] Perhaps her Sisyphean task is a silent indictment of another, far away "white house" with its neo-classical columns arising out of democratic traditions and ideals of justice, democracy and freedom. Painting the ruins white can unify and beautify them, masking malevolent causes. White also pronounces them, issuing stark reminders of the effects of those causes, of how violence often corrupts the loftiest of purposes and imposes the absolutes of faith, ideology or empire. She describes her intention: "At some level, I wanted to make a sculpture that was as much an answer to those who see destruction as a solution to more difficult problems. At the same time, I wanted to preserve these ruins for the future. Just as ruins. Not monuments."[97] Bleaching the damage leaves the ruins intact but also symbolically creates a new, blank space that is far from the didactic monument. Those who confront this space, on site or in distant galleries, can project their own version of past, present or future. *White House* becomes an elegant yet somber stage for imagination, against oblivious blue skies.

The oblivion of the landscape emerges in the photographs of **Tomoko Yoneda** who returns us to former theaters of world wars. Like Abdul, she rejects official histories and the monuments that convey them. Instead, she

turns to the mute eloquence of the invisible in the landscape—places where current beauty or blandness camouflage past dramas. The *Scene* series portrays locations throughout Eastern and Western Europe, China and Japan that were once sites of strife and trauma and that still bear the stamp of past events. *Hill* (2002) and *Pond* (2002) are among the resulting works that confirm that "history often expresses itself impassively in many intangible ways," presenting vistas that are often unremarkable. [98] W.G. Sebald also contemplates former battlegrounds and memorial sites, recognizing the inevitability of the mundane: "The night after the battle, the air must have been filled with death rattles and groans. Now there is nothing but the silent brown soil."[99]

Yoneda's images are discreet reminders of the legacy of violence. They also gently suggest that time *can* heal wounds, even if they are never forgotten. Decades later, rubble from an Allied bombing becomes a hill of patchy grass in Berlin. A serene pond grows from the crater of a WWI mine explosion in Belgium, reflecting an ordinary sky. Following catastrophe, the appeal of the ordinary is extraordinary.

Artists migrate between the mundane and the miraculous. Like the "someone" at the close of Szymborska's poem, they lie with their backs to memory and their faces turned upward. The boundaries between self and world dissolve. Breathing becomes seeing. Gazing at the clouds, the past swallows and is swallowed while the rubble still protrudes from below. We imagine rising above it, allowing the future to form. The end becomes the beginning.

NOTES

1. Cathy Caruth, "Traumatic Awakenings" in *Violence, Identity, and Self-Determination*, ed. Hent de Vries and Samuel Weber (Stanford: Stanford University Press, 1997), 208.

2. Susan Sontag, *Regarding the Pain of Others* (New York: Farrar, Straus and Giroux, 2003), 101-102.

3. Nicole Smith, "Converging Themes in War and Poetry: Szymborska and Komunyakaa," *Article Myriad*, 2010. http://www.articlemyriad.com/war_poetry_themes_szymborska_komunyakaa.htm

4. Mieke Bal, "The Pain of Images" in *Beautiful Suffering*, ed. Mark Reinhardt, Holly Edwards and Erinna Duganne (Chicago: Williams College Museum of Art in association with the University of Chicago Press, 2007), 94.

5. Ibid., 110.

6. Jill Bennett, *Empathic Vision: Affect, Trauma and Contemporary Art* (Stanford: Stanford University Press, 2005), 3.

7. Ibid., 8.

8. Ibid., 9.

9. Bennett, *Empathic Vision*, 3.

10. Caruth, "Traumatic Awakenings," 208.

11. Elaine Scarry, *The Body in Pain: The Making and Unmaking of the World* (Oxford: Oxford University Press, 1985).

12. Bal, "The Pain of Images," 100-01.

13. Bertolt Brecht quoted in David Levi Strauss, *Between the Eyes: Essays on Photography and Politics* (New York: Aperture, 2003), 8.

14. Strauss, *Between the Eyes*, 6.

15. Bal, "The Pain of Images," 105.

16. Ingrid Sischy, "Good Intentions," *The New Yorker,* September 9, 1991, quoted and discussed in Strauss, *Between the Eyes*, 8.

17. Eduardo Galeano, *An Uncertain Grace: Photographs by Sebastião Salgado*, trans. Asa Zatz (New York: Aperture Foundation, 1990), 12.

18. Ibid., 11.

19. Strauss, *Between the Eyes*, 9.

20. Paraphrasing of Avital Ronell's translation of Jacque Derrida's assertions concerning how every photograph poses itself as this question, as discussed in Strauss, *Between the Eyes*, 3.

21. Mark Reinhardt, Holly Edwards and Erinna Duganne, *Beautiful Suffering*, ed. (Chicago: Williams College Museum of Art in association with the University of Chicago Press, 2007), 8.

22. Tim Adams, "Traveler from an antique land," *The New Statesman*, October 1, 2009. http://www.newstatesman.com/art/2009/10/kiefer-art-germany-france

23. W.G. Sebald, "Air War and Literature," from *On the Natural History of Destruction*, trans., Anthea Bell (New York: Random House, 2003), excerpted by Daniel Baird, "A Storm Blowing from Paradise: Anselm Kiefer's Heaven and Earth," *The Walrus*, June 2006.

24. Mark Rosenthal, "Art With a Purpose: The Continuing Saga of Anselm Kiefer" in *Anselm Kiefer: Sculpture and Painting from the Hall Collection* (Cologne: Walther Konig/Derneburg/MASS MoCA Publications, 2008). http://www.massmoca.org/pdf/kiefer_brochure.pdf

25. Anselm Kiefer quoted in Gagosian Gallery press release, March 4, 2009. http://www.gagosian.com/exhibitions/2009-04-03_anselm-kiefer/

26. "Palace of the Republic (Berlin)," *Wikipedia.* http://en.wikipedia.org/wiki/Palace_of_the_Republic_(Berlin)

27. Kiefer, Gagosian Gallery press release.

28. Brian Dillon, "Grey eminence," *The Guardian,* December 5, 2009. http://www.guardian.co.uk/culture/2009/dec/05/julie-mehretu-painting-exhibition

29. Andrew Russeth, "All That's Solid Explodes into Air: An Interview with Julie Mehretu," *Artinfo*, May 25, 2010. http://www.artinfo.com/news/story/34746/all-thats-solid-explodes-into-air-an-interview-with-julie-mehretu/

30. Simon Norfolk, "Afghanistan: Chronotopia" on the artist's web site, concerning *Afghanistan: Chronotopia: Landscapes of the Destruction of Afghanistan* (Stockport, UK: Dewi Lewis Publishing, 2003). http://www.simonnorfolk.com/

31. John Culshaw, *Rachmaninov: The Man and his Music* (Oxford: Oxford University Press, 1949), 73. http://en.wikipedia.org/wiki/Isle_of_the_Dead_(painting)

32. Robert C. Morgan, "The Meaning of Silence," *The Brooklyn Rail*, May 2005. http://www.brooklynrail.org/2005/05/rt/the-meaning-of-silence

33. Ibid.

34. Ibid.

35. Quoted from W.G. Sebald, *The Rings of Saturn*, trans. Michael Hulse (New York: New Directions, 1999) on http://bldgblog.blogspot.com/2006/03/bunker-archaeology.html

36. J.G. Ballard, "A handful of dust," *The Guardian*, March 20, 2006. http://www.guardian.co.uk/artanddesign/2006/mar/20/architecture.communities

37. Bertolt Brecht quote sourced to "Nordseekrabben," *Gesammelte Werke: Prosa* (Frankfurt am Main: Suhrkamp Verlag, 1967), 1:135. http://en.wikipedia.org/wiki/Wikipedia:Reference_desk/Archives/Humanities/2010_September_9

38. Sary Zananiri, "Here," essay for the exhibition "Between Here and Somewhere Else," Palestinian Art Court - Al Hoash, Jerusalem, April 22 - May 13, 2010. http://www.betweenhere.net/Jerusalem/Essay.html

39. "Between Here and Somewhere Else," exhibition statement, Palestinian Art Court - Al Hoash, Jerusalem, April 22 - May 13, 2010. http://www.betweenhere.net/Jerusalem/Exhibition.html

40. Script for "Mea Culpa," for an apparent video production, found online. http://www.brianprince.com/file_cabinet/marykelly/SCRIPT/meaculpa.html

41. Wisława Szymborska, "The End and the Beginning," trans. Joanna Trzeciak, *Miracle Fair: Selected Poems of Wisława Szymborska* (New York: W.W. Norton & Company, Inc., 2001).

42. Jennifer Karady, "Soldiers' Stories Statement," 2010. http://jenniferkarady.com/soldier_statement.html

43. Monica Haller, "The Veterans Book Project," statement on project website, 2010. http://www.veteransbookproject.com/the-veterans-book-project/

44. Luke Leonard, *Luke Leonard: Objects of Deployment*, @Monica Haller, 2010 and published on demand by Lulu, from the *Veterans Book Project* series. http://www.veteransbookproject.com/book/luke-leonard/attachment/vbp_luke_leonard_001/

45. Nathan Lewis, *Nathan Lewis: Objects of Deployment*, @Monica Haller, 2010 and published on demand by Lulu, from the *Veterans Book Project* series. http://www.veteransbookproject.com/book/nathan-lewis-2/attachment/vbp_nathan_lewis_001/

46. Jonathan Watkins, "On Cold Dark Matter," for Chisenhale Gallery, London, 1991. http://www.tate.org.uk/colddarkmatter/texts4.htm

47. Colin Renfrew, "Formation Processes." http://www.tate.org.uk/colddarkmatter/texts4.htm

48. Rollo Romig, "On and Off the Walls: Liu Bolin, Hiding in the City," *The New Yorker*, May 26, 2010. http://www.newyorker.com/online/blogs/photobooth/2010/05/liu-bolin-hiding-in-the-city.html

49. Dr. Ezzeldeen Abu al-Aish, *I Shall Not Hate* (New York: Walker & Company, 2011).

50. Andrew Ellis Johnson, artist statement, February 4, 2011.

51. Quoted from Johnson, artist statement.

52. Xu Bing, "Where Does the Dust Itself Collect?" http://www.xubing.com/index.php/site/projects/year/2004/where_does_the_dust_itself_collect

53. Laura U. Marks, "Adel Abidin's 'Baghdad Travels,'" *Nafas Art Magazine*, July 2007. http://universes-in-universe.org/eng/nafas/articles/2007/adel_abidin

54. Adel Abidin, artist website. http://www.adelabidin.com/index.php?option=com_content&task=view&id=113&Itemid=93

55. Marks, "Adel Abidin's 'Baghdad Travels.'" http://universes-in-universe.org/eng/nafas/articles/2007/adel_abidin

56. Galerie Sfeir Semler press release for "Taysir Batniji: Mobile Home," September 9 - October 3, 2010, and email correspondence with the artist, December 27, 2010. http://www.re-title.com/exhibitions/archive_SFEIRSEMLERHamburg9213.asp

57. Elaine Spatz-Rabinowitz, "Suface to Air," 2008, artist statement.

58. Ibid.

59. Kenneth Baker, "Calamities Transformed at Mills," *San Francisco Chronicle*, September 9, 2006, E-10. http://www.sfgate.

com/cgi-bin/article.cgi?f=/c/a/2006/09/09/DDGJVL1M2E1.DTL

60. Kavi Gupta Gallery press release for "Curtis Mann: everything after," October 23, 2010 - January 30, 2011. http://kavigupta.com/exhibition/everythingafter

61. Enrique Castrejon, 2010 artist statement.

62. From "The Most Beautiful Disasters in the World," statement on Christoph Draeger's web site, composed from excerpts from various sources. http://www.christophdraeger.com/categories/data/categories/01_Photography

63. Ashley Rawlings, "Remote Repercussions: Wafaa Bilal," *ArtAsiaPacific Magazine*, March/April, 2011. http://artasiapacific.com/Magazine/72/RemoteRepercussionsWafaaBilal

64. Wafaa Bilal, 2009 posting on artist's website for "Forbidden Junctions," a group exhibition at the Israeli Center for Digital Art. http://wafaabilal.com/

65. "21 Grams." http://en.wikipedia.org/wiki/21_Grams

66. Samina Mansuri, "Recent Work 2007–2009," statement from artist's website. http://www.saminamansuri.ca/recentmain.html

67. Walid Raad, quoted on the Guggenheim Collection online. http://www.guggenheim.org/new-york/collections/collection-online/show-full/piece/?search=let%27s%20be%20honest&page=1&f=quicksearch&cr=1

68. From "Color Chart: Reinventing Colour, 1950 to Today," Tate Liverpool, May 29 – September 13, 2009. http://www.tate.org.uk/liverpool/exhibitions/colourchart/artists/raad.shtm

69. IDEA sarl Consultants, "Project R," statement on consultants' website. http://www.ideacon.com/projectR.html

70. Bojan Preradovic, "Turning the Rubble of War into a Temporary Residence," *The Daily Star Lebanon*, August 28, 2007. http://www.dailystar.com.lb/article.asp?edition_id=1&categ_id=1&article_id=84857#axzz1HlMy3eSI

71. "Haiti one year on. Edinburgh aid worker at heart of Haiti rebuilding effort," *Oxfam in Action*, January 12, 2011, and "CBF Responds to Haiti – Update," Cooperative Baptist Fellowship of Arkansas, as of September 27, 2010. http://www.oxfam.org.uk/applications/blogs/scotland/2011/01/haiti_1_year_on_edinburgh_aid.html and http://www.cbfar.org/disaster-response/index.html

72. Decolonizing Architecture, "Project Return to Nature," on Decolonizing Architecture Art Residency website. http://www.decolonizing.ps/site/?page_id=210

73. Ibid.

74. Lenka Clayton, "Repairing Lebanon," statement on artist's website. http://www.lenkaclayton.co.uk/gallery.php?gallery=lebanon&mode=portfolio

75. All quotes from Jane Dixon, "Regeneration," statement on artist's website. http://www.janedixon.net/

76. elin o'Hara slavick, *Bomb After Bomb: A Violent Cartography*, with foreword by Howard Zinn, text by Carol Mavor and interviews by Catherine Lutz (Milan: Edizioni Charta, 2009).

77. elin o'Hara slavick, "Hiroshima: After Aftermath," *Critical Asian Studies* 41:2 (2009), p. 309. http://www.unc.edu/~eoslavic/aftermath.pdf

78. elin o'Hara slavick, "Hiroshima: A Visual Record," *The Asia-Pacific Journal*, vol. 30-3-09, July 27, 2009. http://www.japanfocus.org/-elin_o_Hara-slavick/3196

79. The author acknowledges the odd circumstance of writing about her sister, her partner Andrew Ellis Johnson and herself within the context of this book. All of us share professional, political and personal concerns and have collaborated and participated in numerous projects together.

80. Eleanor Heartney, "Evidence at Hand," *R&R&R* (Pittsburgh: Pittsburgh Center for the Arts, 2008), 9.

81. "Empathic unsettlement" as defined by Dominick La Capra in *Writing History, Writing Trauma* (Baltimore: The Johns Hopkins University Press, 2000), 41.

82. Paul Krainak, "Rendering unto Cedars," *R&R&R* (Pittsburgh: Pittsburgh Center for the Arts, 2008), 16.

83. Rocío Rodríguez, email correspondence with the author, October 11, 2010.

84. Ikon Gallery overview of the 2010 European premiere of *Seeing One's Own Eyes*. http://www.ikon-gallery.co.uk/programme/

current/event/365/seeing_ones_own_eyes/

85. From the essay by curator and artist MadeIn for "Seeing One's Own Eyes: Contemporary Art from the Middle East," ShanghArt Gallery, Shanghai, China, 2009, 3. http://issuu.com/bjartlab/docs/madein-seeing_ones_own_eyes

86. Ikon Gallery overview of the 2010 European premiere of *Seeing One's Own Eyes*. http://www.ikon-gallery.co.uk/programme/current/event/365/seeing_ones_own_eyes/

87. Ibid.

88. From "Artist Talk: Diana Al-Hadid" on Art Babble. http://www.artbabble.org/video/hammer/artist-talk-diana-al-hadid

89. Milan Kundera, *The Curtain: An Essay in Seven Parts*, translated by Linda Asher (New York: Harper Collins, 2007), 27.

90. *Record of a Mortal Universe* is the title of a 2007 sculpture by Diana Al-Hadid.

91. Susan Snodgrass, "Armita Raafat at Three Walls," *Art in America*, March 29, 2010. http://www.artinamericamagazine.com/reviews/armita-raafat/

92. Museum of Contemporary Art Chicago web site statement on the Armita Raafat exhibit, May 2-31, 2009. http://www.mcachicago.org/exhibitions/exh_detail.php?id=222

93. Lida Abdul, "Feminist Artist Statement," Brooklyn Museum, Elizabeth A. Sackler Center for Feminist Art: Feminist Art Base, online. The full quote by Maurice Blanchot is: "The disaster ruins everything, all the while leaving everything intact. It does not touch anyone in particular; 'I' am not threatened by it, but spared, left aside," in *L'Ecriture du désastre* (Paris: Gallimard, 1980), *The Writing of the Disaster*, trans. Ann Smock. (Lincoln: University of Nebraska Press, 1986). http://www.brooklynmuseum.org/eascfa/feminist_art_base/gallery/lida_abdul.php

94. Ibid.

95. Benjamin Genocchio, "Crux of War Depicted in Human Terms," *The New York Times*, March 23, 2008. http://query.nytimes.com/gst/fullpage.html?res=9C06EEDB1E39F930A15750C0A96E9C8B63

96. From "Lida Abdul: In the Factory," Indianapolis Museum of Art. http://www.artbabble.org/video/ima/lida-abdul-factory

97. Lida Abdul, "Works in the exhibition 'Nafas,'" *Nafas Art Magazine*, May 2006. http://universes-in_universe.org/eng/nafas/articles/2006/nafas_special/nafas_exhibition/artists/lida_abdul

98. Tomoko Yoneda in Enoch Cheng's "Interview with Tomoko Yoneda," *Asia Art Archive*. http://www.aaa.org.hk/newsletter_detail.aspx?newsletter_id=631

99. W.G. Sebald, *The Rings of Saturn* (London: Harville Press, 1998), as excerpted by Guy Moreton in "Terror Unscene: Meditations on Tomoko Yoneda's Photography," ed. Graham Coulter Smith and Maurice Own, *Art in the Age of Terrorism* (London: Paul Holberton Publishing, 2006), 206-211.

WORKS

LIDA ABDUL

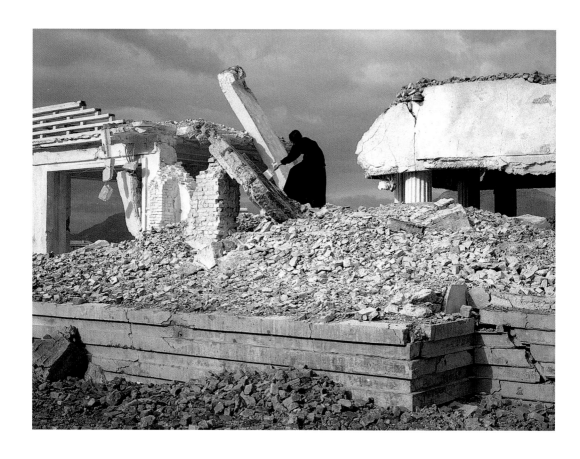

WHITE HOUSE, 2005
VIDEO STILLS FROM 16MM FILM ON DVD, 4:58 MINUTES
© LIDA ABDUL, COURTESY OF GIORGIO PERSANO, TURIN

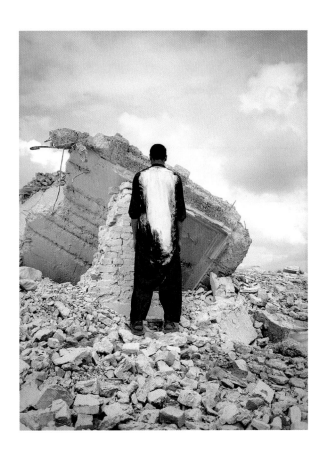

ADEL ABIDIN

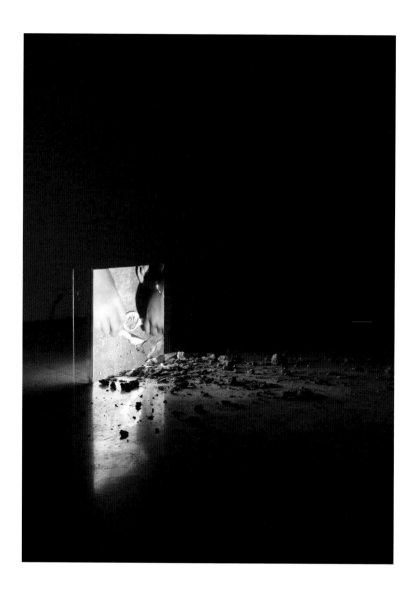

CONSTRUCTION SITE, 2006
VIDEO AND SOUND INSTALLATION WITH TRANSLUCENT PLEXIGLASS, PROJECTOR, DVD PLAYER,
SPEAKER AND RUBBLE
COURTESY OF THE ARTIST

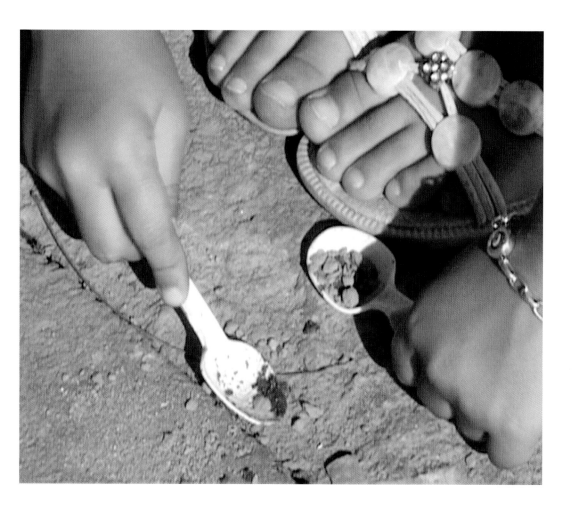

CONSTRUCTION SITE (DETAIL), 2006

DIANA AL-HADID

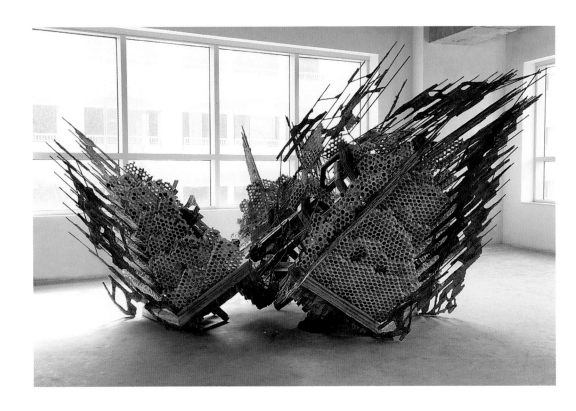

BUILT FROM OUR TALLEST TALES, 2008
WOOD, METAL, POLYSTYRENE, POLYMER GYPSUM, FIBERGLASS, PLASTIC, CONCRETE AND PAINT,
144 x 100 x 80 INCHES
© DIANA AL-HADID, COURTESY OF THE ARTIST AND MARIANNE BOESKY GALLERY
PHOTO: MARIANO C. PEUSER

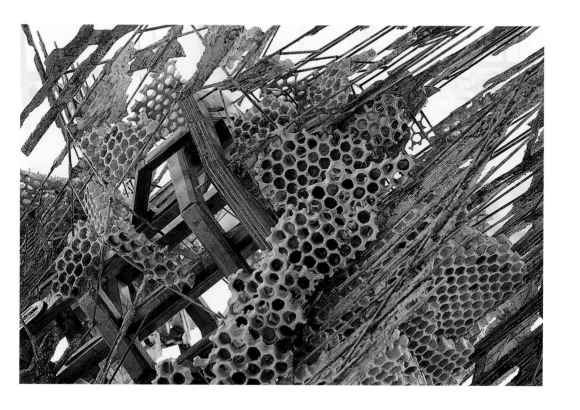

BUILT FROM OUR TALLEST TALES (DETAIL), 2008

JENNIFER ALLORA & GUILLERMO CALZADILLA

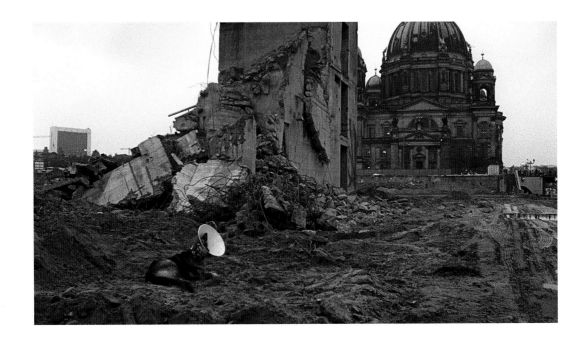

HOW TO APPEAR INVISIBLE, 2009
STILLS FROM SUPER 16MM FILM TRANSFERRED TO HD VIDEO, 21:26 MINUTES
© ALLORA & CALZADILLA, COURTESY OF GLADSTONE GALLERY, NEW YORK

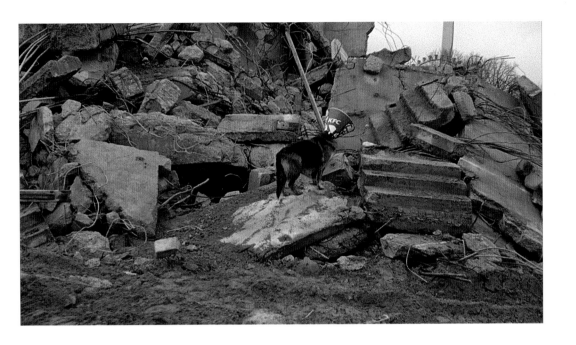

TAYSIR BATNIJI

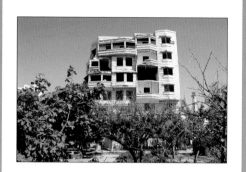

North of Al Shati refugee camp,
150 m from the beach

Area: 320 m² on 1250 m² of land. Ground floor: reception room, warehouses. 5 floors composed each of 3 rooms, living room, dining room, kitchen, 2 bathrooms/wc. 900 m² orchard of olive trees, fig trees, vines, and a fountain. Garage in the garden. Unrestricted sea view. Inhabitants: 5 families (23 people)

GH0809

GH0809

THE GH0809 SERIES: GH0809, HOUSE 1, 2010
DIGITAL COLOR PRINTS ON PAPER, 11.6 x 8.3 INCHES EACH; WITH PLEXIGLAS, 13.8 x 10.6 INCHES
FROM 103 DIGITAL PRINTS OF 33 GAZAN HOMES PHOTOGRAPHED IN 2008-09, SHORTLY AFTER
ISRAELI OPERATION CAST LEAD, AND PRESENTED AS REAL ESTATE PROPERTY ADS.
COURTESY OF GALERIE SFEIR-SEMLER

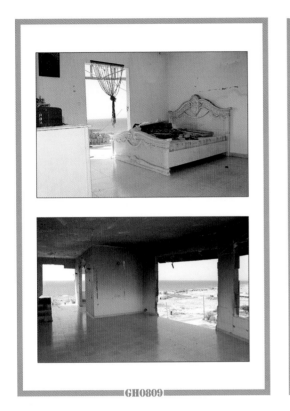

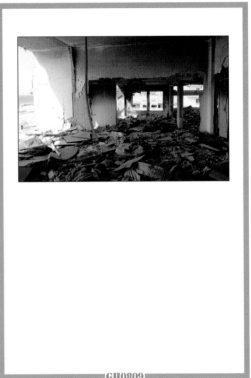

GH0809

GH0809

WAFAA BILAL

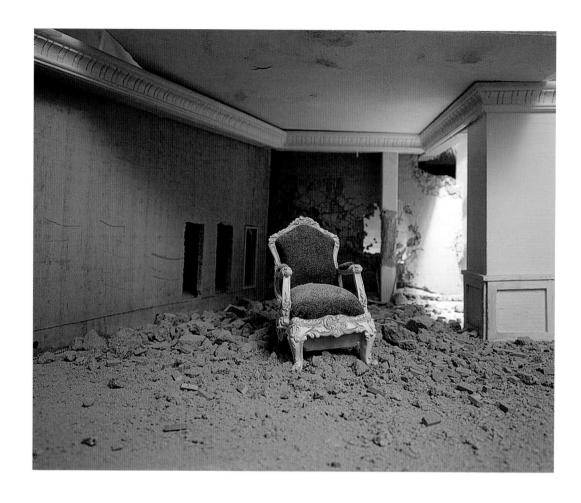

THE ASHES SERIES, 2009
ARCHIVAL INKJET PRINTS MOUNTED ON DIEBOND, 40 x 60 INCHES EACH

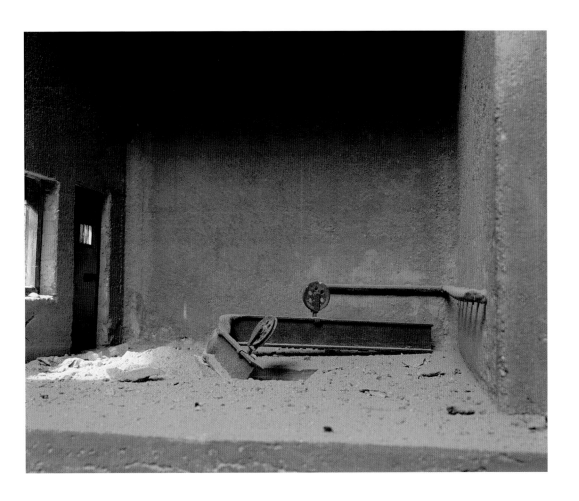

XU BING

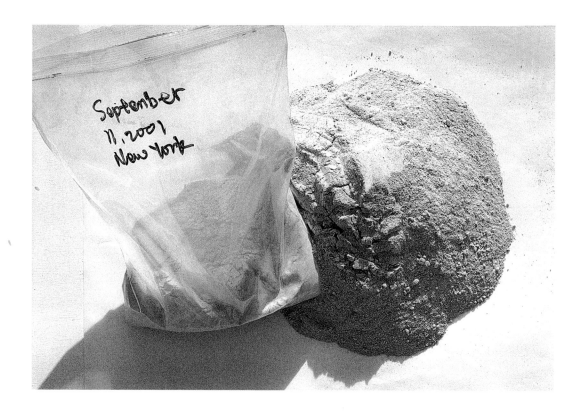

WHERE DOES THE DUST COLLECT ITSELF? (DETAIL), 2004
DUST COLLECTED AFTER 9/11 FOR PROCESS OF MOLDING DOLL FOR SUBSEQUENT TRANSPORTATION
AND REGRINDING INTO POWDER TO BLOW AND SETTLE OVER STENCILED TEXT ON FLOOR,
14.5 x 5.9 x 3.9 INCHES FOR INSTALLATION ON SITE
COURTESY OF XU BING STUDIO

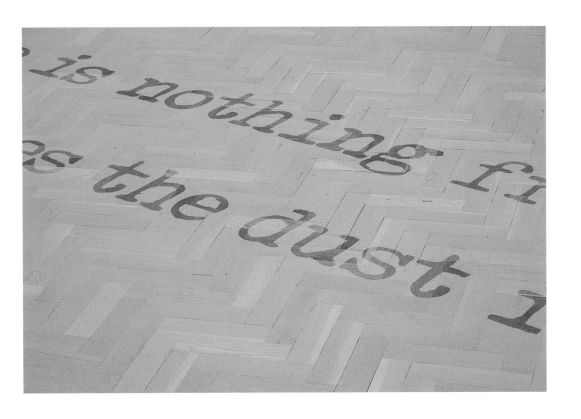

WHERE DOES THE DUST COLLECT ITSELF? (DETAIL), 2004
9/11 DUST, STENCILED TEXT, SCAFFOLDING;
INSTALLATION VIEW AT NATIONAL MUSEUM CARDIFF, WALES, 27.4 x 28.3 FEET

LIU BOLIN

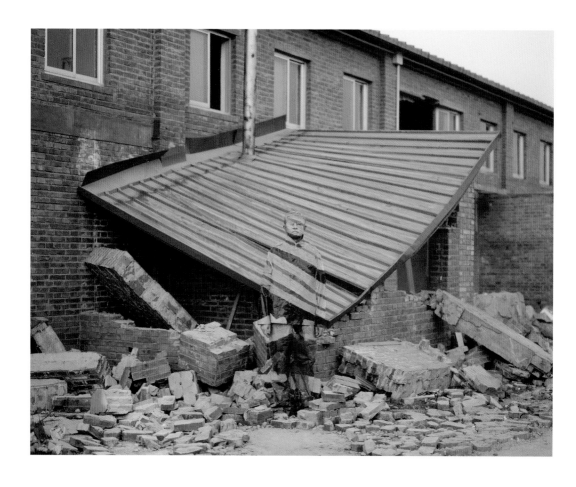

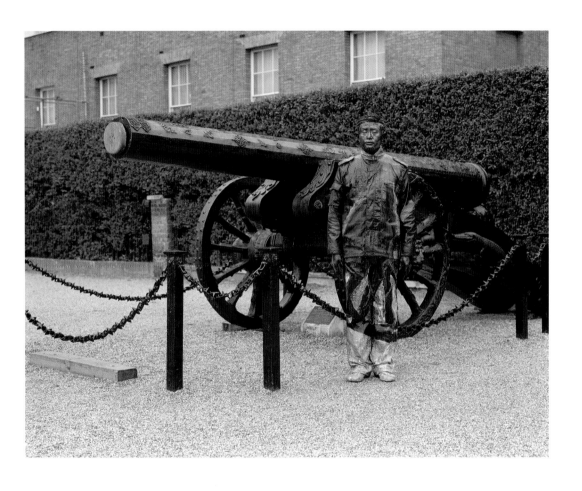

HIDING IN THE CITY NO. 67 — ARTILLERY, 2007
DIGITAL C-PRINT, 46.5 x 59 INCHES
COURTESY OF VANGUARD GALLERY

ENRIQUE CASTREJON

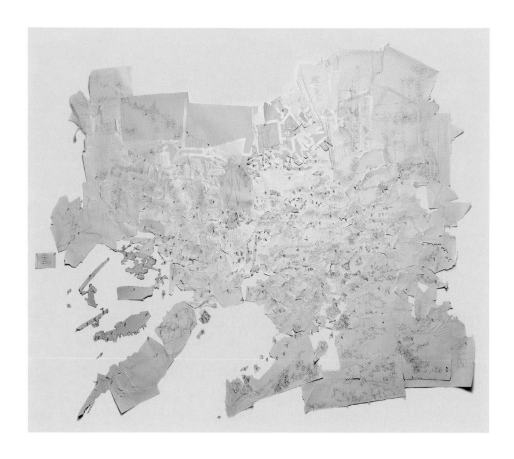

WASTELAND: NAJAF, 2005
ADHESIVE TAPE, PENCIL, INK, THUMBTACKS ON PAPER, 8 X 10 FEET
COURTESY OF THE ARTIST

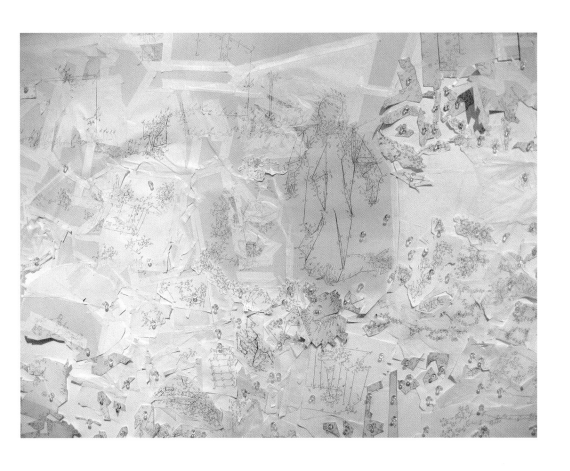

WASTELAND: NAJAF (DETAIL), 2005

LENKA CLAYTON

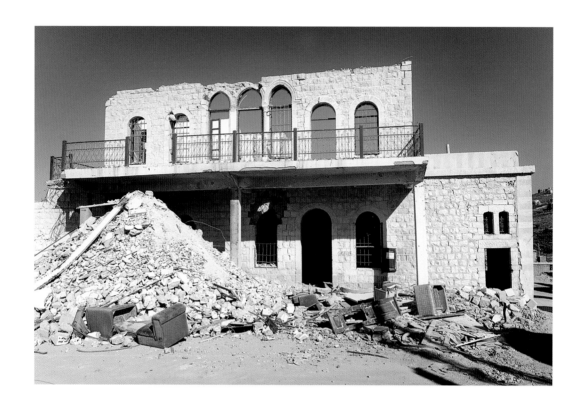

REPAIRING LEBANON, 2007
FROM A SERIES OF FIVE SETS OF DIGITALLY MANIPULATED IMAGES OF BUILDINGS IN LEBANON
DAMAGED IN THE 2006 CONFLICT WITH ISRAEL, DIMENSIONS VARIABLE
COURTESY OF THE ARTIST

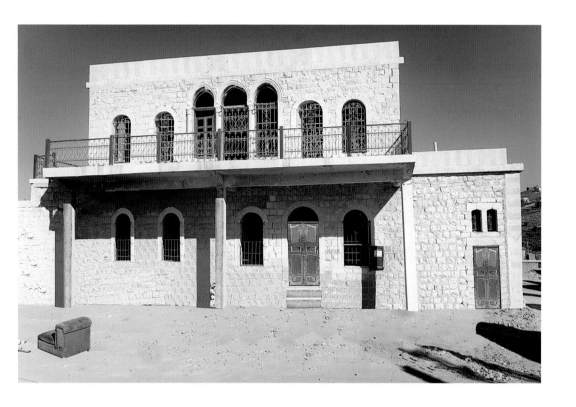

HELEN DE MAIN

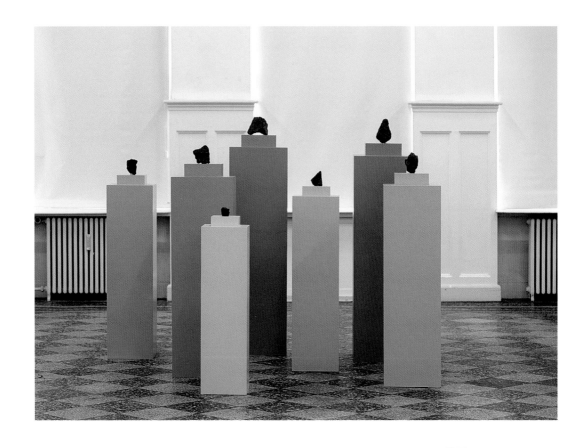

SILWAN HOARD — ABASI FAMILY, 2010
BRONZE, MDF, PAINT, DIMENSIONS VARIABLE
FROM "BETWEEN HERE AND SOMEWHERE ELSE" EXHIBITION
PHOTO: ANDERS SUNE BERG

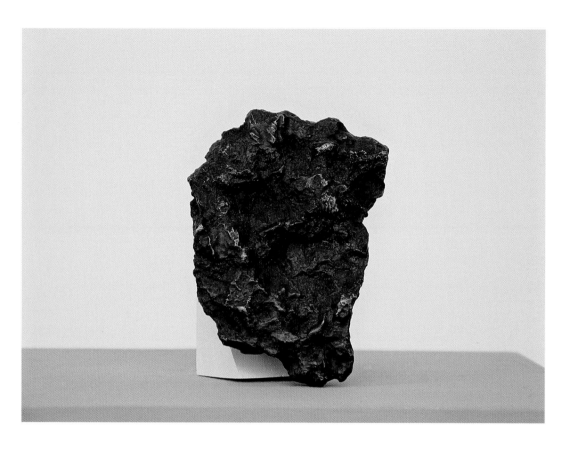

SILWAN HOARD — ABASI FAMILY (DETAIL), 2010

DECOLONIZING ARCHITECTURE

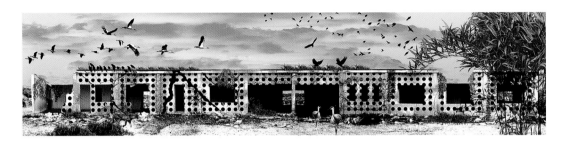

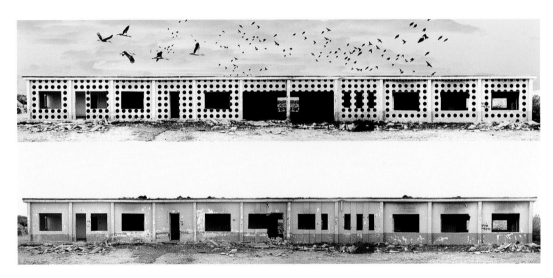

PROJECT: RETURN TO NATURE, 2007-ONGOING
PHOTOMONTAGES OF CONVERSION OF BUILDINGS IN OUSH GRAB, A FORMER ISRAELI MILITARY BASE, TO A BIRD OBSERVATORY IN BETHLEHEM

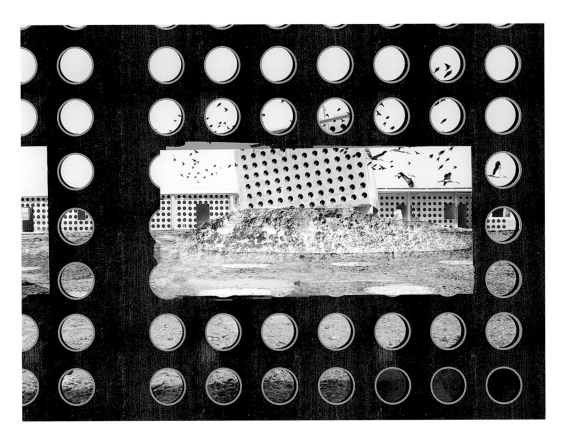

JANE DIXON

TOKYO 2, 2008
OIL, PIGMENT ON GESSO AND POLYESTER, 56.3 x 42.1 INCHES
COURTESY OF THE ARTIST

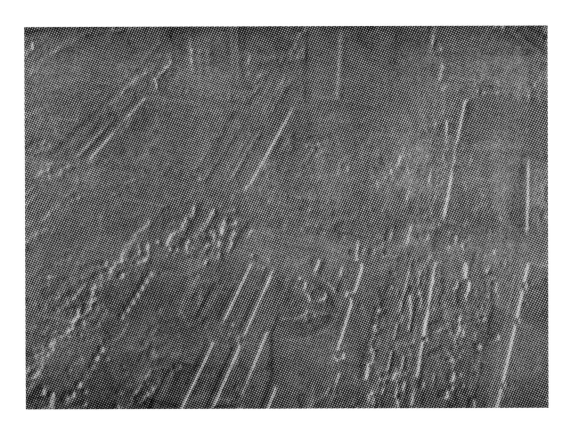

REGENERATION III (YOKOHAMA), 2006
ETCHING, 23.2 X 32.7 INCHES
COURTESY OF THE ARTIST

CHRISTOPH DRAEGER

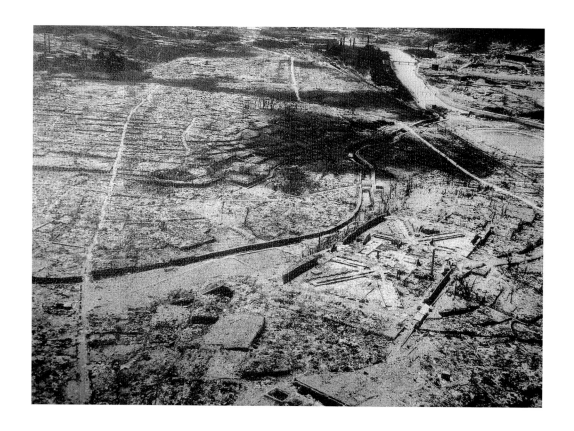

NAGASAKI, AUG 9 1945, 2008
ULTRAVIOLET PRINT ON JIGSAW PUZZLE (8000 PIECES), 61.4 x 85 INCHES
COURTESY OF GALERIE ANNE DE VILLEPOIX, PARIS

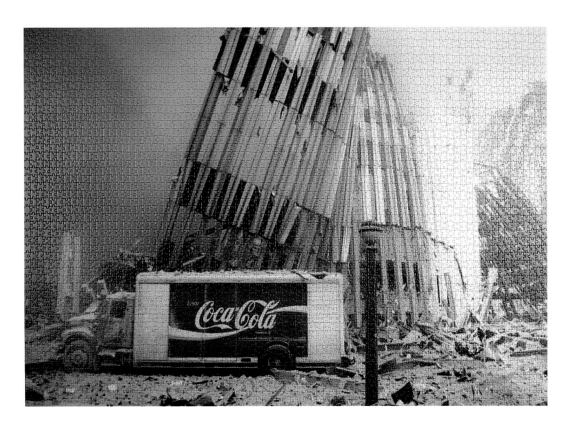

GROUND ZERO, NEW YORK, SEP 11 2001 (COCA COLA), 2003
ACRYLIC PAINT JET ON JIGSAW PUZZLE (4000 PIECES), 45.7 x 61.4 INCHES
PRIVATE COLLECTION, PHOTO CREDIT: DOUG KANTER / SIPA PRESS

MONICA HALLER

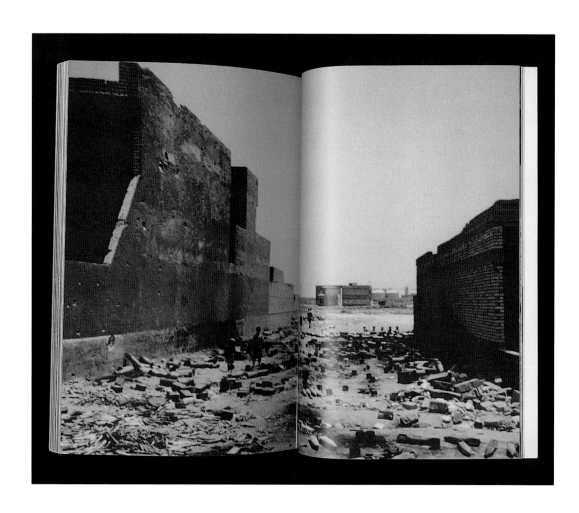

NATE LEWIS, IRAQ, 2003
PUBLISHED IN 2010 AS PART OF THE **VETERANS BOOK PROJECT**
(DEVELOPED IN COLLABORATION WITH VETERANS), PAGES 111-112,
DIGITAL PRINT IN SOFTBOUND BOOK, 12 X 6 INCHES
© MONICA HALLER AND PUBLISHED ON DEMAND BY LULU

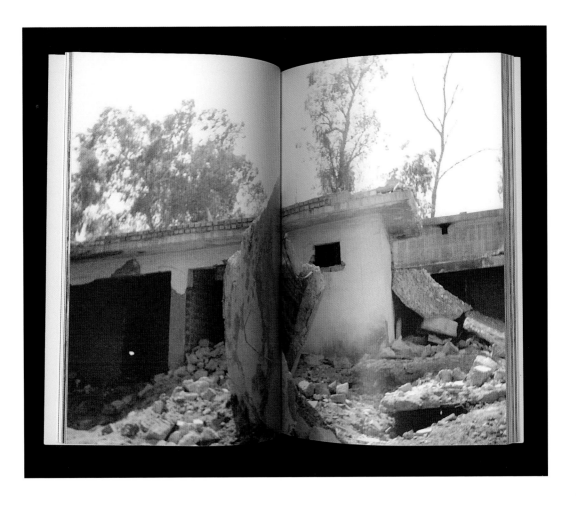

LUKE LEONARD, IRAQ, 2003
PUBLISHED IN 2010 AS PART OF THE **VETERANS BOOK PROJECT**
(DEVELOPED IN COLLABORATION WITH VETERANS), PAGES 33–34
DIGITAL PRINT IN SOFTBOUND BOOK, 12 x 6 INCHES
© MONICA HALLER AND PUBLISHED ON DEMAND BY LULU

IDEA SARL – CONSULTANTS (NACHAAT OUAYDA & SAMI MARKUS)

03 CONCEPTUAL WALL & FLOOR CONSTRUCTION

CONCEPTUAL ROOF CONSTRUCTION

PROJECT R, 2006
CONCEPTUAL WALL, FLOOR AND ROOF DESIGNS
COURTESY OF IDEA SARL

PROJECT R, 2006
ON SITE PROTOTYPE FOR ONE UNIT (112 SQUARE METERS) TO DEMONSTRATE PIONEERING, COST
AND ENVIRONMENTALLY EFFECTIVE SYSTEM FOR RECYCLING RUBBLE RESULTING FROM WARS OR
EARTHQUAKES INTO TRANSITIONAL OR PERMANENT STRUCTURES

ANDREW ELLIS JOHNSON

FORMAL GRAFFITI: HA' (OU KHA' OU DJIM), 2011
ARCHIVAL COLOR INKJET PRINT, DIMENSIONS VARIABLE
COURTESY OF THE ARTIST

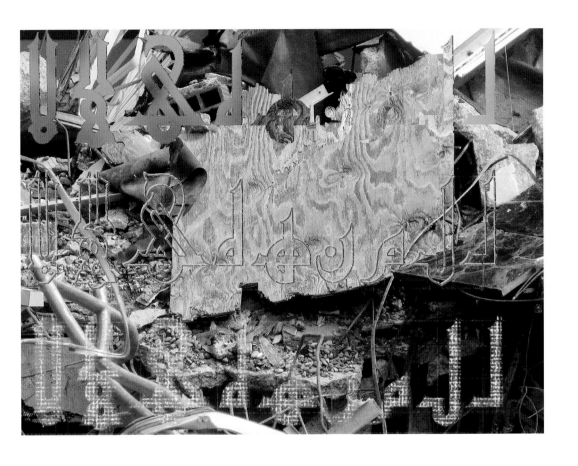

FORMAL GRAFFITI: LAM, MIIM, NOUN, HA' ET LA': I, 2011
ARCHIVAL COLOR INKJET PRINT, DIMENSIONS VARIABLE
COURTESY OF THE ARTIST

JENNIFER KARADY

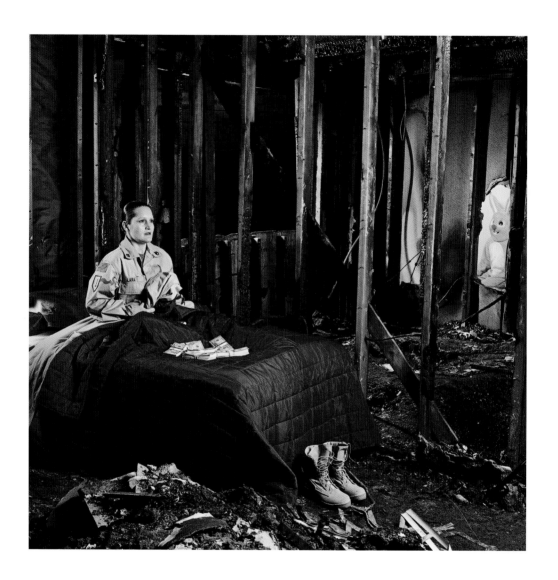

SOLDIERS' STORIES FROM IRAQ AND AFGHANISTAN
FORMER STAFF SERGEANT STARLYN LARA, C DETACHMENT, 38TH PERSONNEL SERVICES BATTALION, 1ST INFANTRY DIVISION, U.S. ARMY, VETERAN OF OPERATION IRAQI FREEDOM, TREASURE ISLAND, SAN FRANCISCO, CA, JANUARY 2010. NARRATIVE ON P. 138, C-PRINT, 48 X 48 INCHES

SOLDIERS' STORIES FROM IRAQ AND AFGHANISTAN
FORMER SERGEANT STEVE PYLE, U.S. ARMY, 101ST AIRBORNE DIVISION, VETERAN OF THE SHOCK
AND AWE INVASION OF IRAQ, WITH WIFE DEBBIE, AND CHILDREN, STEVEN, BROOKE, CASSIE, CHLOE,
MICHAELA, MANDY, AND BRANDI, DELAND, FL, JULY 2006. NARRATIVE ON P. 139,
C-PRINT, 48 x 48 INCHES

MARY KELLY

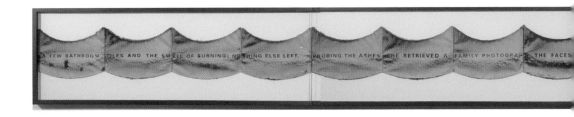

MEA CULPA (SARAJEVO, 1992), 1999
COMPRESSED LINT, 17 X 235 X 2 INCHES
COURTESY OF POSTMASTERS GALLERY

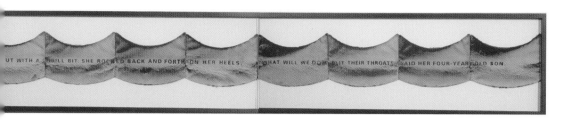

OSMAN KHAN

THE DESTRUCTION OF THE HOUSE OF ABU AL-AISH (STILLS), 2009
COMPUTER, CEILING-MOUNTED MONITOR, WOOD, STEEL WIRE, CUSTOM COMPUTER PROGRAM

ANSELM KIEFER

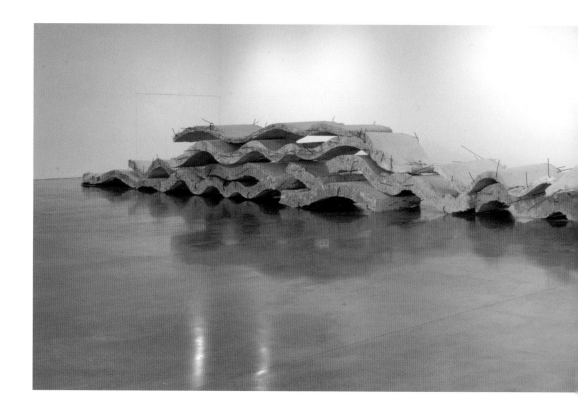

ETROITS SONT LES VAISSEAUX (NARROW ARE THE VESSELS), 2002
CAST CONCRETE, EXPOSED REBAR AND LEAD, 82 FEET LONG
© ANSELM KIEFER, COURTESY OF GAGOSIAN GALLERY

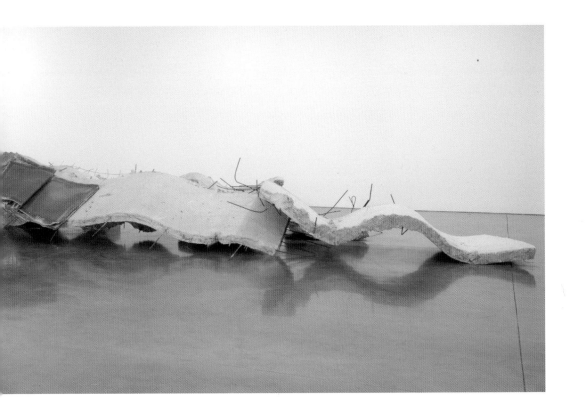

BARRY LE VA

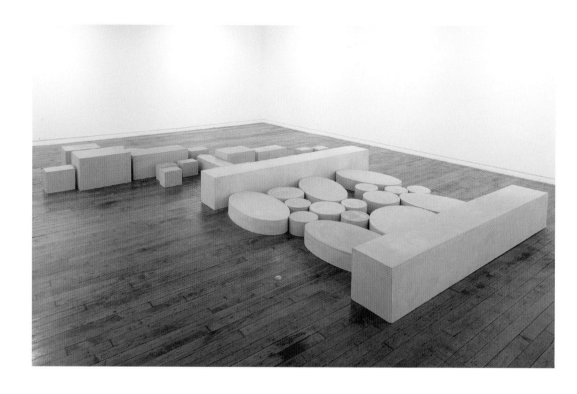

FROM THE RUBBLE: SORTED, CLASSIFIED, SEALED, 1995
CAST ULTRA CAL, LUTEX, SAND, 235 x 172 x 17 INCHES
COURTESY OF SONNABEND GALLERY

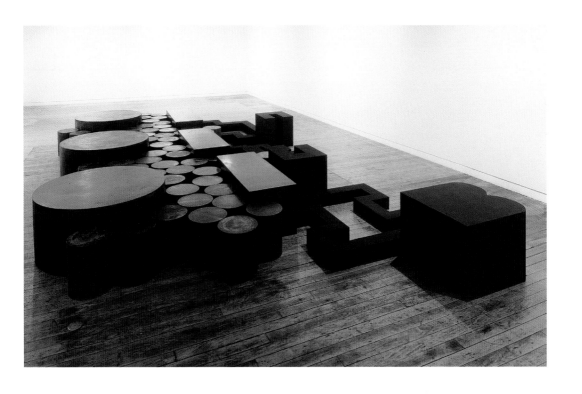

BUNKER COAGULATION (PUSHED FROM THE RIGHT), 1995
CAST HYDRA-STONE, RUBBER, 252 x 144 x 20 1/2 INCHES
INSTALLATION VIEW AT SONNABEND GALLERY, 1995
HALL COLLECTION, COURTESY OF MARY BOONE GALLERY, NEW YORK

MADEIN COMPANY (XU ZHEN)

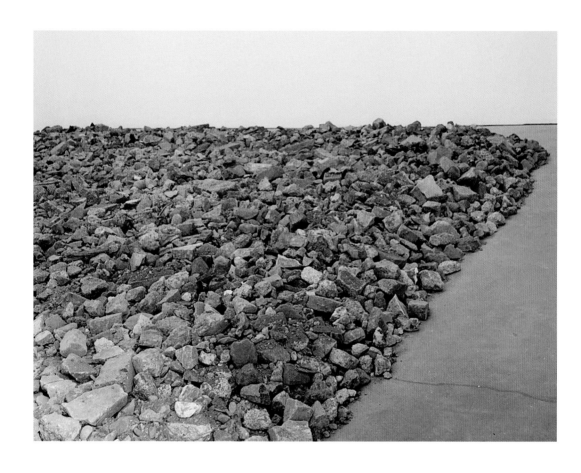

CALM, 2009
WATERBED, CARPET, BRICKS, 196.9 x 137.8 INCHES
"SEEING ONE'S OWN EYES" INSTALLATION, IKON, 2010
PHOTO: STUART WHIPPS

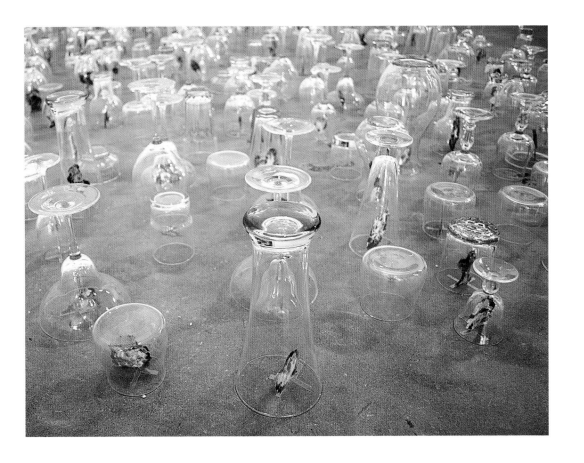

THE COLOUR OF HEAVEN, 2009
"SEEING ONE'S OWN EYES" INSTALLATION, IKON, 2010
PHOTO: STUART WHIPPS

CURTIS MANN

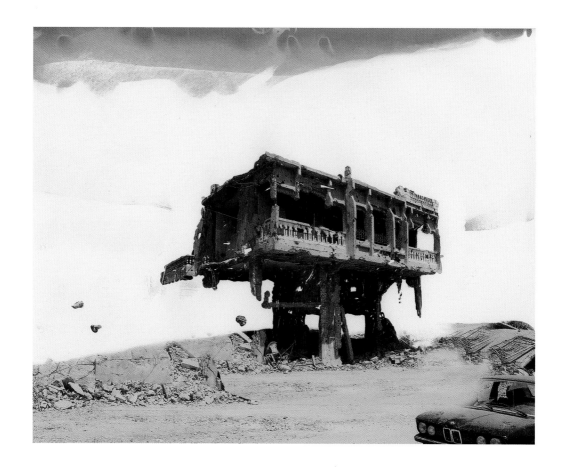

BUILDING, STANDING (BEIRUT), 2008
SYNTHETIC POLYMER VARNISH ON BLEACHED CHROMOGENIC DEVELOPMENT PRINT,
11 x 14 INCHES
COURTESY OF THE ARTIST AND KAVI GUPTA GALLERY, CHICAGO │ BERLIN

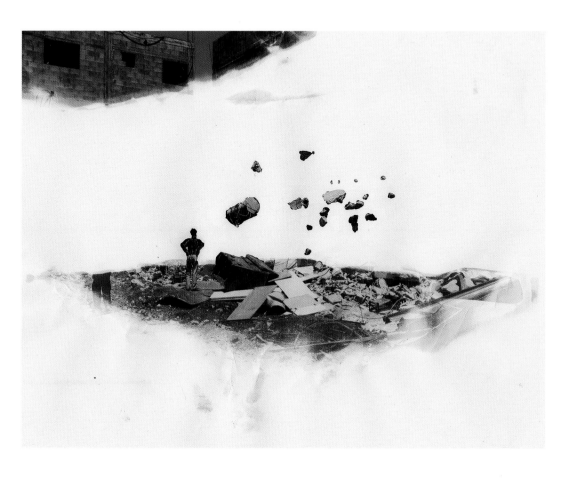

REMAINS OF A HOME (INCURSION), 2007
SYNTHETIC POLYMER VARNISH ON BLEACHED CHROMOGENIC DEVELOPMENT PRINT,
16 x 20 INCHES
COURTESY OF THE ARTIST AND KAVI GUPTA GALLERY, CHICAGO | BERLIN

SAMINA MANSURI

DIGAR (04), DIGAR (17), OLARA (12), DIDADARAE (10) (CLOCKWISE), 2008
GICLEE PRINTS ON HAHNEMÜHLE ARCHIVAL PHOTO RAG, 8 X 10 INCHES
COURTESY OF THE ARTIST

OLARAAEE, 2008
GICLEE PRINT ON HAHNEMÜHLE ARCHIVAL PHOTO RAG, 44 x 34.6 INCHES
COURTESY OF THE ARTIST

RAQUEL MAULWURF

LUFTANGRIFF BERLIN APRIL '45, 2008
CHARCOAL/PASTEL ON MAT BOARD, 8.3 x 10.6 INCHES
PHOTO: ARTIST, COURTESY OF FREDERIEKE TAYLOR GALLERY AND THE ARTIST

FLIEGERANGRIFF AUF BERLIN APRIL '45, 2008
CHARCOAL/PASTEL ON MAT BOARD, 28 x 39.8 INCHES
PHOTO: PETER COX, COURTESY OF FREDERIEKE TAYLOR GALLERY AND THE ARTIST

JULIE MEHRETU

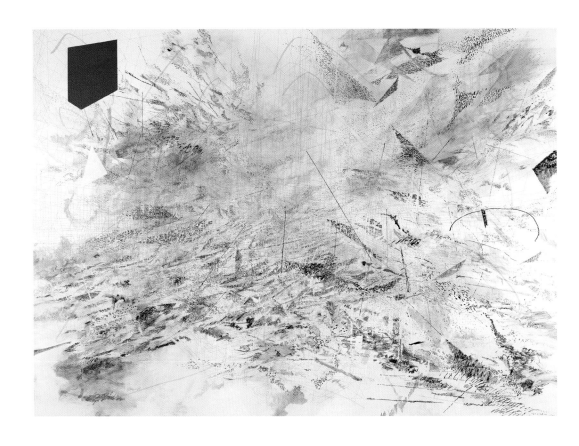

ATLANTIC WALL, 2009
INK AND ACRYLIC ON CANVAS, 119 7/16 x 167 1/4 INCHES
COURTESY OF MARIAN GOODMAN GALLERY

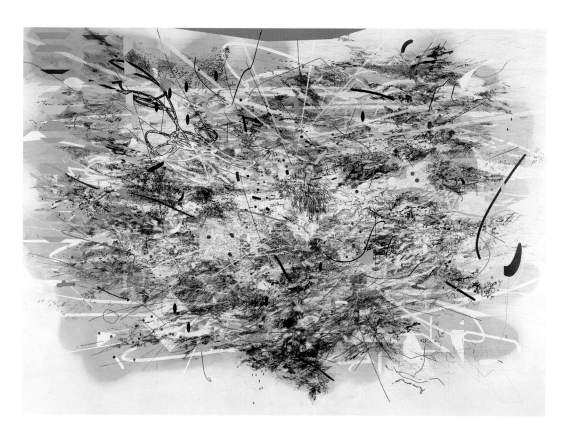

MIDDLE GREY, 2009
INK AND ACRYLIC ON CANVAS, 119 7/16 x 166 7/16 INCHES
COURTESY OF MARIAN GOODMAN GALLERY

SIMON NORFOLK

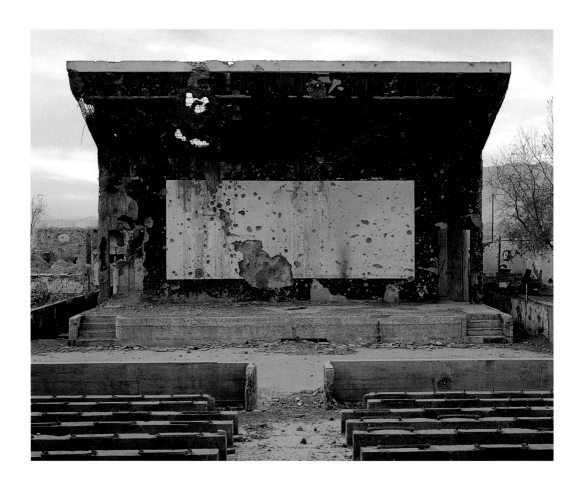

AFGHANISTAN: CHRONOTOPIA: BULLET-SCARRED OUTDOOR CINEMA AT THE PALACE
OF CULTURE, KARTE CHAR DISTRICT OF KABUL, 2001
ARCHIVAL DIGITAL CHROMOGENIC PRINT, 40 x 50 INCHES
© SIMON NORFOLK

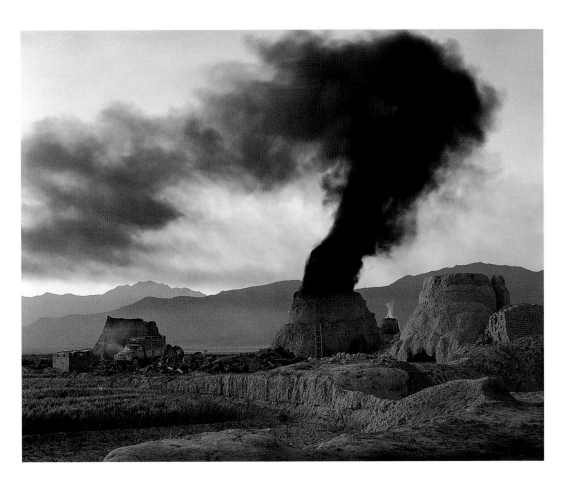

AFGHANISTAN: CHRONOTOPIA: THE BRICKWORKS AT HUSSAIN KHIL,
EAST OF KABUL, 2001
ARCHIVAL DIGITAL CHROMOGENIC PRINT, 40 x 50 INCHES
© SIMON NORFOLK

CORNELIA PARKER

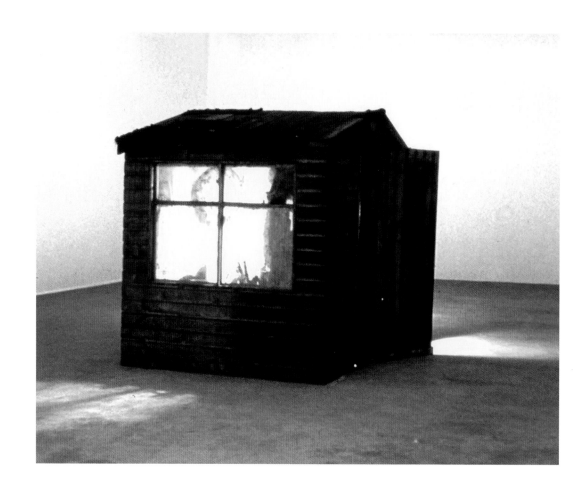

COLD DARK MATTER: AN EXPLODED VIEW, 1991
A GARDEN SHED AND CONTENTS BEFORE BEING BLOWN UP FOR THE ARTIST BY THE BRITISH ARMY,
ILLUMINATED BY A SINGLE LIGHT BULB, DIMENSIONS VARIABLE
COURTESY OF THE ARTIST AND TATE

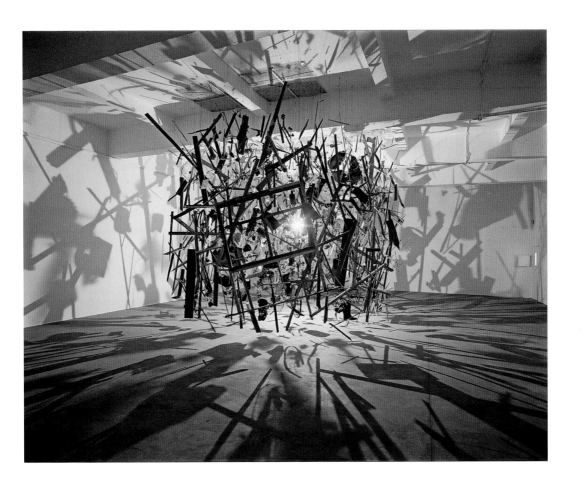

COLD DARK MATTER: AN EXPLODED VIEW, 1991
A GARDEN SHED AND CONTENTS BLOWN UP FOR THE ARTIST BY THE BRITISH ARMY, THE FRAGMENTS
SUSPENDED AROUND A LIGHT BULB, DIMENSIONS VARIABLE
COURTESY OF THE ARTIST AND TATE

LET'S BE HONEST, THE WEATHER HELPED (FINLAND), 1984-2007
ARCHIVAL COLOR INKJET PRINT, ONE OF A SERIES OF 17 PRINTS, 18 1/4 x 28 1/4 INCHES
© WALID RAAD, COURTESY OF PAULA COOPER GALLERY, NEW YORK

LET'S BE HONEST, THE WEATHER HELPED (EGYPT), 1984-2007
ARCHIVAL COLOR INKJET PRINT, ONE OF A SERIES OF 17 PRINTS, 18 1/4 x 28 1/4 INCHES
© WALID RAAD, COURTESY OF PAULA COOPER GALLERY, NEW YORK

ARMITA RAAFAT

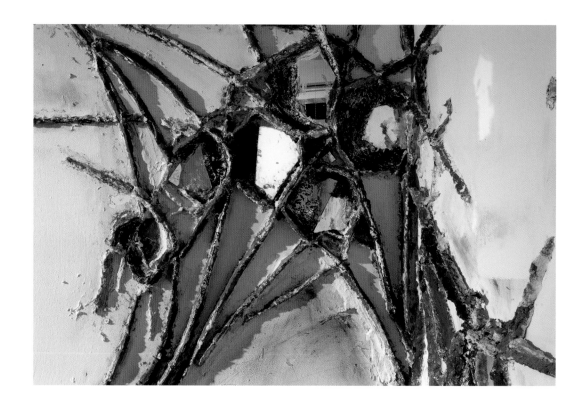

UNTITLED (DETAIL), 2008
FROM INSTALLATION AT SULLIVAN GALLERIES, SCHOOL OF THE ART INSTITUTE OF CHICAGO
COURTESY OF THE ARTIST

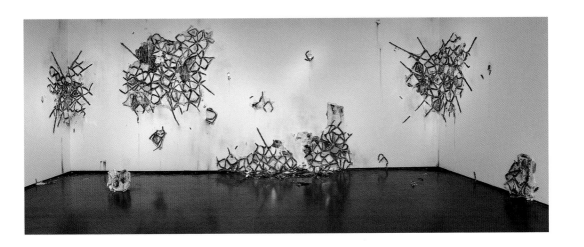

UNTITLED, 2009
2009 INSTALLATION AT THE MUSEUM OF CONTEMPORARY ART, CHICAGO
COURTESY OF THE ARTIST

ROCÍO RODRÍGUEZ

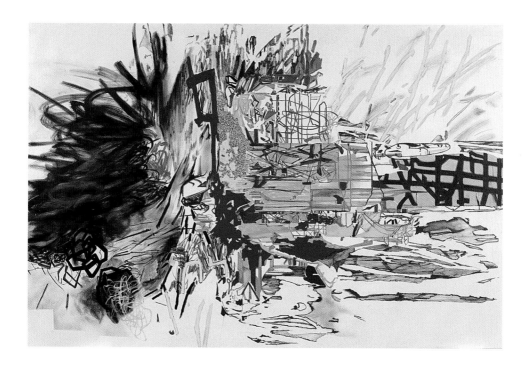

CRUSH, 2009
OIL ON CANVAS, 72 x 109 INCHES
COURTESY OF THE ARTIST

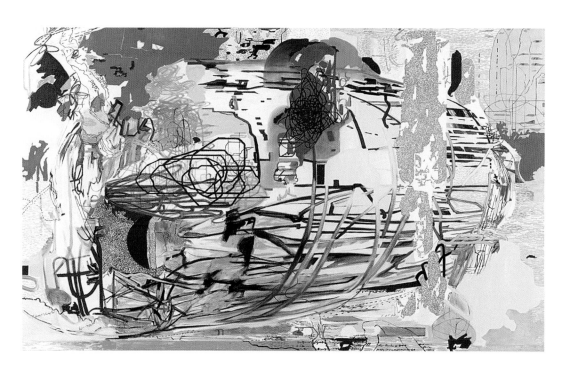

BAGHDAD, THE ROUND CITY, 2007
OIL AND ACRYLIC ON CANVAS, 72 x 120 INCHES
COURTESY OF THE ARTIST

THOMAS RUFF

JPEG NY05, 2004
C-PRINT WITH DIASEC, 111.42 x 66.14 INCHES FRAMED, EDITION OF 3
COURTESY OF DAVID ZWIRNER GALLERY
© 2011 ARTISTS RIGHTS SOCIETY (ARS), NEW YORK / VG BILD-KUNST, BONN

ELIN O'HARA SLAVICK

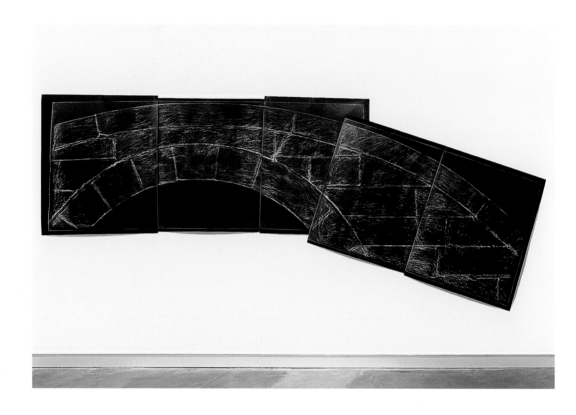

KOKO BRIDGE RECONSTRUCTED, 2009
SILVER GELATIN CONTACT PRINT OF A FROTTAGE, 25 X 6 FEET
COURTESY OF THE ARTIST

TREE STUMP, 2008
SILVER GELATIN CONTACT PRINT MADE FROM AN AUTORADIOGRAPH OF AN A-BOMBED TREE
FRAGMENT, FROM THE HIROSHIMA PEACE MEMORIAL MUSEUM ARCHIVE, PLACED ON A SHEET OF
X-RAY FILM IN LIGHT-TIGHT CONDITIONS FOR TEN DAYS
COURTESY OF THE ARTIST

SUSANNE SLAVICK

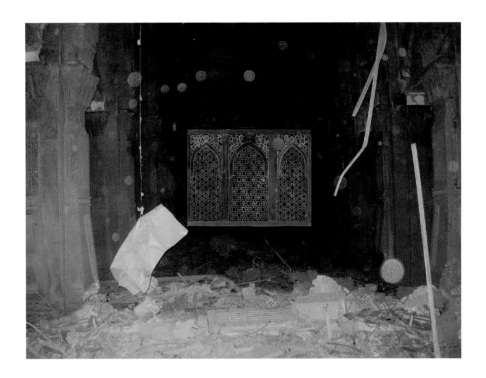

RESILIENCE II, 2008
GOUACHE ON ARCHIVAL INKJET PRINT ON HAHNEMÜHLE PAPER, 18 X 24 INCHES
GRILLE PATTERN FROM 16TH-CENTURY TOMB OF MUHAMMED GHAUS IN GWALIOR, INDIA
ALTERED SOURCE IMAGE: WEBSHOTS, JOHNDRUMMER16, ALBUM#5 IRAQ 2005
COURTESY OF THE ARTIST

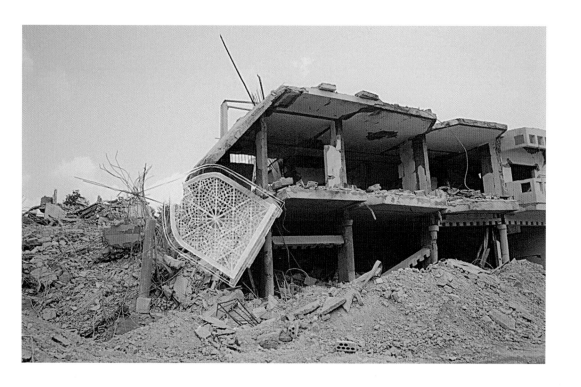

RESTORATION (THRESHOLD I), 2006
GOUACHE ON ARCHIVAL INKJET PRINT ON HAHNEMÜHLE PAPER, 10 x 16 1/8 INCHES
ALTERED SOURCE IMAGE OF KHIYAM, LEBANON AFTER ISRAELI BOMBING TAKEN AUGUST 21, 2006
BY M. ASSER ON FLICKR
COURTESY OF THE ARTIST

ELAINE SPATZ-RABINOWITZ

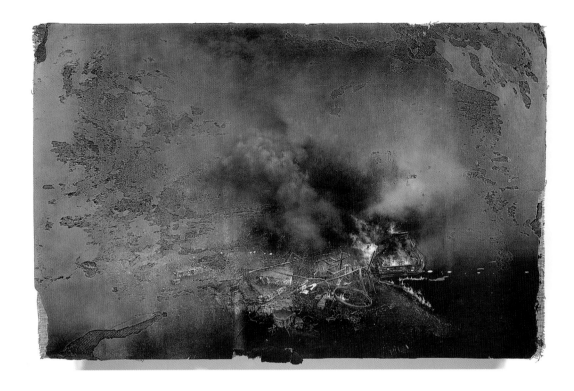

NEAR THE AIRPORT, BEIRUT, JULY, 2006, 2006
OIL ON CAST PIGMENTED HYDROCAL, 17 x 26 x 2 INCHES
COURTESY OF THE ARTIST

IRAQI DITCH, 2005, 2005
OIL ON CAST PIGMENTED HYDROCAL, 48 x 67 x 2 INCHES
COURTESY OF THE ARTIST

PAMELA WILSON-RYCKMAN

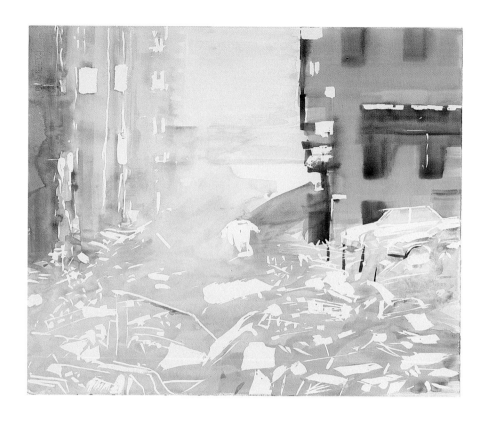

CORNER (LEFT), 2007
WATERCOLOR ON PAPER, 22 1/2 x 27 1/2 INCHES
PRIVATE COLLECTION, SAN FRANCISCO
COURTESY OF GALLERY PAULE ANGLIM AND THE ARTIST

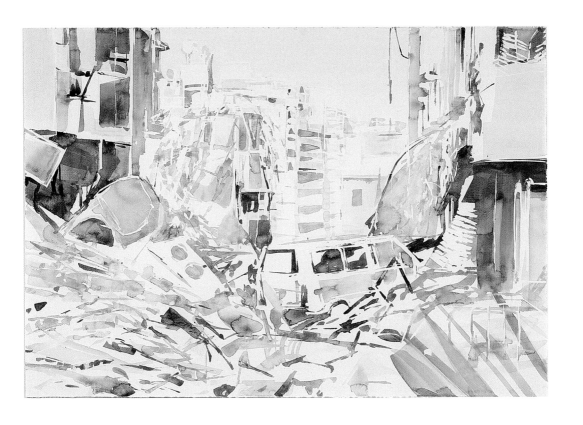

CORNER (RIGHT), 2007
WATERCOLOR ON PAPER, 20 1/2 x 30 INCHES
PRIVATE COLLECTION, SAN FRANCISCO
COURTESY OF GALLERY PAULE ANGLIM AND THE ARTIST

TOMOKO YONEDA

SCENE: HILL (HILL MADE OF RUBBLE AFTER ALLIED BOMBING, BERLIN, GERMANY), 2002
C-TYPE PRINT, 41.7 x 49.2 INCHES
COURTESY OF THE ARTIST

SCENE: POND (POND CREATED BY WWI MINE EXPLOSION, MESSINES RIDGE, BELGIUM), 2002
C-TYPE PRINT, 41.7 x 49.2 INCHES
COURTESY OF THE ARTIST

Holly Edwards

WHAT IF...

Trauma, in other words, is timeless.[1]
——Robert Stolorow

Go, go, go said the bird: human kind
Cannot bear very much reality.
Time past and time future
What might have been and what has been
Point to one end, which is always present.
——"Burnt Norton," *Four Quartets*, T.S. Eliot

Years ago, Eliot pondered time and the taxations of reality. His words are still moving, though the world has changed considerably since he wrote. In the wake of the tsunami off Japan, catastrophe seems a frame frozen around us; news from Afghanistan, Iraq or Libya a grim blur. Even from a vantage point of insulated comfort, reality can seem unbearable, unspeakable. Scholars call this trauma culture,[2] and as therapists will tell us, trauma is pre-verbal and timeless—silent and still.

In the preceding pages, Susanne Slavick has orchestrated a project of hope, exploring how artists have dealt with ruin—how they register, represent and recuperate from trauma—and how we respond to, and benefit from, their images. Following her lead, I am consoled by *Calm*, wherein only heaving breath continues; I take respite in the work of Elaine Spatz-Rabinowitz, paint controlling pain with precise power. I suppose you might say that I traffic in abstraction, ethics and aesthetics converging in general terms. I do admit my comfort and privilege. I lived in Afghanistan once, before war came to that land. Now, I teach art history in the bucolic bubble of New England and I presume to hope for Afghanistan from a distance, in part because I don't know what else to do. But the artists included in this volume do not shrink from rubble. What if we follow them?

Lida Abdul has said that Afghanistan "is a country that performs so many

LIDA ABDUL
DOME, 2005
STILL FROM 16MM
FILM TRANSFERRED
TO DVD, 4:50
MINUTES
© LIDA ABDUL, 2007
COURTESY OF
GIORGIO PERSANO,
TURIN

psychological tasks for the larger world: it is a failed state; it is a tragedy; it is the incarnation of a land that is unconquerable, etc. Afghanistan is the place where all the melodramatic clichés of the so-called West come to die and then the media rehashes them as orientalism. It's a country that is a metaphor for so many things: freedom of women, war, warlords, a country of resistance…"[3] Indeed, the country is iconic of conflict and intractable quandaries. At least three artists presented here—Lida Abdul, Simon Norfolk and Susanne Slavick—engage with this icon, albeit in different media—video, photography and painting. All three address that landscape of ruined buildings and blighted spaces, but they operate in different registers and none of them stops with wreckage.

Lida Abdul, for example, seeks "a reconciliation with the past that is neither a desire for revenge nor a complete erasure of the past in order to start anew…" She speaks of "healing processes that open a space of mourning for me."[4] Here perhaps is an entrée into thinking about making art out of Afghanistan, that paradigmatic case of sustained trauma. Reconciliation, mourning, healing—these words describe processes, processes of shifting towards recuperation and hope. Any such change, I think, is ineluctably tangled with time, for both are about differencing one moment from the next. It is but a short step then to suggest that this art rooted in Afghanistan may be therapeutic precisely because it manipulates time, something so vast and obscure, and yet so familiar and prosaic.

But how are we to think about time? Watches mark time, calendars organize it. The changing seasons suggest that time marches on… Rituals shape it

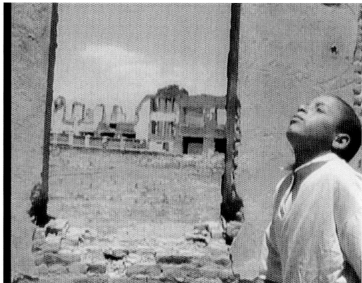

for spiritual purpose, while gods stand aside altogether. It is something special indeed that we call "timeless" or "eternal." Awareness of the apparent implacability of time and the wherewithal to know its implications—especially mortality—are the most recent of evolutionary acquisitions; humans are alone in this capacity. And yet, time itself remains enigmatic. Physicists comment on its shape and character, while anthropologists see it as an index of culture, asking how it is conceived, used and experienced in different contexts.[5] Is it linear, cyclical, homogenous, symbolic or simply ephemeral? Theorists note the experiential complexities of time and its layeredness, at once cumulative, discontinuous and heterogeneous.[6] Just about everyone will agree that time can be simultaneously long and short—time flies, after all, when we are having fun.

Time wobbles, however, when we are not. Indeed, psychologists and social workers point to the diverse distortions of time that manifest in the wake of serious trauma.[7] Myriad time disorders (e.g. time-skew and omen formation) result from extreme stress, powerful instincts working to defend the traumatized individual from further pain. When challenging events occur, critical parts of the brain (the amygdale and hippocampus) respond and compensate; dissociation follows and memories are laid down without reference to time, place or coherent narrative.[8] The result is often a silent and timeless realm in which ordinary notions of causality do not apply. The original trauma cannot be described because it cannot be remembered clearly but it resurfaces unpredictably, wrenching the person out of everyday time and place, disoriented.

But if one's time sense is indicative of pain suffered, it is also a critical site

for/of recuperative work—a medium in which healing can happen and hope can emerge. Setting aside the work of professional therapists, trauma culture has spawned interdisciplinary helpers of all kinds. Literary scholars, for example, focus on the therapeutic potential of the activity of reading. Wendy O'Brien has argued that "Literature as such begins in the time outside of time where those who suffer trauma reside. And slowly, as the page turns, it brings the survivor back, reminds her of another time. As such, it restores a sense of time. [...] Not yet ready or able to narrate, reading becomes a process through which time is recreated."[9] Thus ushered back in the realm of words, a survivor of trauma can find a way to accommodate and ameliorate the past and, in so doing, find the will to act again. Visual art can work similarly, even before words can be found, affording steps back into the arena of action and agency. Griselda Pollock has described certain images as a "transit station" for artist and viewer, a transitional space defined by coming to terms with time past and affording access to the present/future. She has stated trenchantly, "The past only arrives when there is a future to contain it."[10] The artists that I will discuss below understand this, I think, and they handle time like clay for their own benefit and ours.

Lida Abdul, for example, is familiar with the silent aftermath of trauma. She speaks of the "history of silence," and her project is situated at that liminal cusp between immobility and action, that moment when recuperation begins. By her own admission, Abdul experienced a turning point when she unexpectedly witnessed a boy dancing beneath a damaged dome.[11] The youth was alone and the architecture was pockmarked and fragmentary. Birds chirp, the wind blows, and the boy's step is touchingly innocent; we move closer. Then, as we look up into the dome with him, the sun-lit space is invaded by the drone of a military helicopter overhead. The turning accelerates. The boy dances on.

While video is a medium of time, this particular time-piece is deceptively simple. Abdul admits that none of what she recorded was choreographed; rather, she happened upon it by accident and, in the moment even, it seemed an extraordinary confluence—the sanctifying ruin, the whirling boy and the droning helicopter. Abdul turns this witnessing to acknowledgment and then to art. The curative force resides particularly in that subtle soundtrack (birds, wind, steps and drone) and that spinning motion; both transpire in time, modeling change, but they also mark a time out of time, shaped by spontaneous spirit rather than violent causality. The vital quietude under that dome has the distilled and purposeful economy of ritual; indeed, the artist compares the child's innocent turning to the whirl of a dervish and the search for spiritual connection.[12]

Abdul enacts such recuperative processes personally in *White House*,

seeking recovery in artistic practice. Her tools are simple and few. Working solo for three days with one single brush, she paints the rubble of a once grand building, filling the space of mute trauma with stubborn purpose. This is no mere whitewash, although the rubble is marbleized with meaning in the end. This is a ritualized response to catastrophic events and a dogged dedication to the next brushstroke and then the next step—not erasure, but honor; not accusation but acknowledgement. Smoothing over the past is not enough; in a sense, ritual commemoration is necessary.[13] Describing these processes and pictures, the artist often uses the word "beautiful," and the work she produces is, indeed, aesthetically compelling. In *What We Saw Upon Wakening* (2006), men leaning into ropes tied to a venerable ruin continue the work of destruction to end it, their movements and their swaying cables a choreographed act of catharsis. The "beauty" works somatically here, forcing breath, slowing awareness, eliciting recognition. For that time, there is space to mourn and heal. Marking time and reclaiming ruins is custodial hope, a preface to "time future."

Afghanistan is Abdul's birthplace and the site of her practice, but that land does not circumscribe her identity nor does it limit the *meaning* of her project. She has roots in other places as well and her work resonates broadly, in turn—ritualized action commandeers time for new purpose, transforming wreckage of the past. Simon Norfolk was not born in Afghanistan, though his photographs suggest a certain devotion to that land and a stunned awe in the face of its ruin. Describing the devastated country, the artist reverts to childhood imaginings of the Apocalypse and Armageddon: "I felt I had already lived these landscapes in the fiery exhortations of a childhood Manchester Sunday School: utter destruction on an epic Babylonian scale, bathed in the crystal light of a desert sunrise."[14] With these words he might have been describing *The District of Afshar in Western Kabul* (2001*)*. Most of the picture plane is given over to the stumps and shadows of demolished walls. There is no life in that neighborhood anymore; there are only skeletal remains of what once was—past lives, leveled homes, bleak bones.

Even as the destruction stunned the photographer, the photograph awes the viewer, so economically does it sound dissonances between life and death, pain and beauty, wrought of light and shade and a few colors—all browns, ochres and creams. Grass does grow there, denying the monochrome of death, but it is just a glint of green in the foreground. That there are people here at all is striking. Norfolk admits, "If they're in my pictures, it's usually because they represent an idea, really."[15] Those goatherds are emblems, not individuals; they occupy an otherwise ephemeral moment, tending herds, staying warm, sun perpetually setting. We see them but can't hear them, but they are life going on—a modest *present* in the wreckage of the *past*.

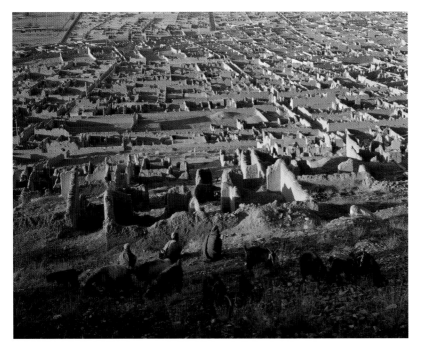

Still, there is more to this arresting image. Time is all laid out here, mapped in formal symmetries. Goats and men fan this way and that around a plumb line down the center, two brown cloaks framing one blue, forming a secondary chord. Herders turn slowly, their attention unfurling from left to right, attention caught by something beyond our view and before our arrival. As Norfolk says, "It's about this panoptic process, it's about this kind of eavesdropping, it's about this ability to look into every aspect of our lives…"[16] And so, we are sideways to their world. We take the long view, straight ahead, beyond the goats and men, deeper into the image. In effect and without thinking, we look across the shepherds' story further into the past, up the middle of the picture towards a door-like break in the ruins beyond. Wending a path through fragmentary spaces, we reach a graveyard, clamber over wall bumps. About dead center, there is one small brave building among the remnants, out beyond a curious rounded hillock and a long relatively unbroken wall. It is incongruous evidence of industry amid the ruins, red window frames intact, modest walls oddly crisp and straight.

On one level, such images read like interrupted, portentous stories. Shepherds look elsewhere expectantly, but what's going on? The theater is damaged and the show is over; what will happen now? Ovens belch black and white smoke; who needs bricks and where are the workmen? But there is a difference between time and storyline. Norfolk's images are not photojournalistic

records of events, though they may sustain specific projections and conjure particular narratives. Rather they seem to encompass and acknowledge many stories of destruction leading up to the present moment. This is a more capacious perspective, a therapeutic anachronism of sorts. We are not meant to know individual people or understand discrete events. Instead, these images capture a palimpsest of wars from the vantage point of reverie. In Norfolk's words, Afghanistan is a chronotopia—"a mirror shattered and thrown into the mud of the past." He explains that "The idea of the chronotope—*chronos* is time, and *topos* is place—is any place where these layers of time fit upon each other. Either satisfactorily or uncomfortably—it fascinates me."[17] For the rest of us, the mere existence of such a vast image *proves* that life does go on in spite of it all, and we are grateful.

Abdul and Norfolk both render architecture and ruin as setting and subject, indicative of endless violence, grappling with the past from the standpoint of the present. Susanne Slavick wields restorative anachronism more pointedly, combining different media towards a conceptual end. To begin, she uses the photographic record of demolished buildings and conflict zones—that visuality from which we all suffer—as the very ground on which to apply color. Digitally reproducing and altering news photos in carefully calibrated monotones, she paints over modern ruins with vignettes drawn from Persian manuscript traditions that flourished centuries ago, most famously in Herat in present day Afghanistan. Such paintings were originally intended to illustrate epics of heroism and tales of romance, and they were lauded by effete connoisseurs for their "realism," generating poetic repartee about the natural world and human experience.[18] While these images convey stories in lively, legible ways, they do not approximate the optical verisimilitude of photojournalism. Slavick capitalizes on this disparity as she scissors time and stitches it back together again; in her hands, the fifteenth century might be neatly bound up with the twenty-first. She says herself that such tailoring can "remind us that peace did once reign and is still possible in places we think of as eternally under siege."[19]

Release: Bird Cage demonstrates the potential of this strategy beautifully. For this piece, Slavick references the *Mantiq al Tayr* in the Metropolitan Museum of Art,[20] a manuscript that is emblematic of the zenith of Herati painting. The particular painting that she quotes is itself a reverie on death and earthly commemoration, a theme sadly resonant with our own times. Slavick has extracted but a part of this larger whole (the tree, nest, snake and cage) and superimposed it on a different ground—the ghastly vestiges of modern-day violence in the region. On first glance, the layered image seems hopeful—the cage hangs open, the birds fly free. Seemingly, they flit between wreckage and "art," prompting us to take heart and consider options. But it is not so

simple; that snake remains. Those birds deserve our concern on other levels too, as the artist explains:

> I see their situation as a powerful metaphor for the notion of "liberation" that nations purport to offer to or impose on those outside of their own borders. What does "freedom" mean when a country is occupied or destroyed? Should one stay, leave or return to home during or after the bombs have fallen?

The cage is complicated: it is a safe place, it is prison, it is home. Should they fly away or stay put? Do they even have a choice?

These are tough questions, and when quandaries of this sort are rendered on large scale and displayed around an entire gallery, as Slavick has done, individual responses may coalesce into collective recognition.

SUSANNE SLAVICK RELEASE: BIRD CAGE, 2008 ARCHIVAL DIGITAL PRINT ON HAHNEMÜHLE PAPER, 72 X 36 INCHES TREE DERIVED FROM "THE SON WHO MOURNED HIS FATHER," FROM THE MANUSCRIPT OF FARID AL-DIN 'ATTAR, CA. 1487

The prod to action lies, I think, in the seams between time present and time past, between ruin and refinement. The artist does not disguise those sutures; rather they are the very subject, those boundaries between photography and painting. Without thinking, we read the former as "reality" and the latter as artistry. We are obliged to determine where we stand in this disturbing face-off.

But if we are caught, silent and still in cages of our own making, we might recall Eliot's words: "What might have been and what has been/Point to one end, which is always present." Then, perhaps we might determine that the time has come… What if, right now, we paint the best of the past over the worst of the present to imagine new options? What if, right now, we take the long view, sideways to the present, to remember our sustained humanity? What if, right now, we do not let the drone interrupt the dance? Might things change then?

NOTES

1. Robert Stolorow, "Trauma and the Hourglass of Time." http://www.huffingtonpost.com/robert-d-stolorow/coping-with-trauma_b_826995.html

2. The phrase "trauma culture" has arguably entered common parlance, but it is also the title of an important book by E. Ann Kaplan, *Trauma Culture: The Politics of Terror and Loss in Media and Literature*, (New Brunswick and London: Rutgers University Press, 2005). Trauma studies, more generally, are a vast discourse rooted in research about the Holocaust.

3. http://www.artslant.com/ny/artists/rackroom/7567

4. http://www.artslant.com/ny/artists/rackroom/7567

5. E.g. Wendy James and David Mills, eds., *The Qualities of Time: Anthropological Approaches*, (New York: Berg Press, 2005); Nancy D. Munn, "The Cultural Anthropology of Time: A Critical Essay," *Annual Review of Anthropology*, vol. 21 (1992), 92-123.

6. E.g. Mieke Bal, "Heterochrony in the Act: The Migratory Politics of Time," *Thamyris/Intersecting*, no. 23 (2011), 211-238.

7. Lenore C. Terr, "Time and Trauma," *Psychoanalytic Study of the Child*, vol. 39 (1984), 633-685.

8. Bibliography on trauma and its treatment has mushroomed in the wake of 9/11. On the consequences and physiology of trauma see Kaethe Weingarten, *Common Shock, Witnessing Violence Every Day: How We are Harmed, How We can Heal*, (New York: New American Library, 2003), esp. 39-54. Other points of reference (among many for this project) include Robert A. Neimeyer, "Traumatic loss and the reconstruction of meaning," *Innovations in End-of-Life Care* 3 (6) 2001 and Francoise Devoine and Jean-Max Gaudilliere, *History Beyond Trauma, Whereof one cannot speak, thereof one cannot stay silent*, (New York: Other Press, 2004), 163-208.

9. Wendy O'Brien "Telling Time: Literature, Temporality and Trauma," *Analecta Husserliana*, 2007, vol. 86, pt. 3, 218.

10. Griselda Pollock, "Aesthetic Wit(h)nessing in Post-Traumatic Cultures," lecture delivered March 15, 2011, Research and Academic Program, Sterling and Francine Clark Art Institute, Williamstown, MA.

11. http://www.artslant.com/ny/artists/rackroom/7567 and http://5centlemonade.wordpress.com/2009/03/20/lida-abdul-dome/

12. http://5centlemonade.wordpress.com/2009/03/20/lida-abdul-dome/

13. http://zine.artcat.com/2007/10/lida-abdul-in-conversation.php

14. Simon Norfolk, *Afghanistan: Chronotopia*, (England: Dewi Lewis Publishing, 2002), n.p.

15. http://bldgblog.blogspot.com/2006/11/warphotography-interview-with-simon.html

16. http://bldgblog.blogspot.com/2006/11/warphotography-interview-with-simon.html

17. http://bldgblog.blogspot.com/2006/11/warphotography-interview-with-simon.html

18. David Roxburgh, "Kamal al-Din Bihzad and Authorship in Persianate Painting," *Muqarnas* vol. 17, 2000, 122-3.

19. Personal communication.

20. *Mantiq al-Tayr* (The Language of the Birds) A.H. 892/A.D. 1487, Herat, Afghanistan. Opaque watercolor, silver and gold on paper. Dimensions: H. 9 3/4 in. (24.8 cm) W. 5 1/2 in. (14 cm) Page: H. 13 in. (33 cm) W. 8 1/2 in. (21.6 cm) Mat: H. 19 1/4 in. (48.9 cm) W. 14 1/4 in. (36.2 cm), Fletcher Fund, 1963; Accession Number 63.210.35 http://www.metmuseum.org/works_of_art/collection_database/islamic_art/mantiq_al_tayr_the_language_of_the_birds/objectview.aspx?page=502&sort=0&sortdir=asc&keyword=&fp=1&dd1=14&dd2=0&vw=1&collID=14&oID=140009073&vT

NARRATIVES FROM JENNIFER KARADY'S SOLDIERS' STORIES FROM IRAQ AND AFGHANISTAN

STARLYN LARA

We were in a convoy between my camp at Kirkush Military Training Base and Camp Anaconda in Balad, which is where everything happens—that's the hub. At the time I was the FOO (Field Ordering Officer) and I was responsible for all of the money that came in and out of the installation. I would convoy very frequently in order to transport money—like a hundred thousand dollars in cash—under my vest.

I was in a Humvee, but our unit isn't a tactical unit, so we didn't have armored Humvees. What we had were Kevlar plates that lined the seats but not the vehicle. They were designed to keep you from dying, but not designed to protect you. When the bomb went off, it actually shot pieces of the engine up. I was in the passenger seat.

As soon as the vehicle exploded, my first thoughts were about the safety of the money. Then there was just all this blood and I didn't know where it was coming from. My ears were ringing from this huge concussion blast. I couldn't hear and my vision was blurred. And so many things were happening. I couldn't make out the sounds around me—I was disoriented. I was looking—the windows were shattered and my arms were cut, I was bleeding, and I just couldn't figure out where all of the blood was coming from. It seemed like forever but it probably took place in the blink of an eye.

There are many things that connect me back to that moment. It's usually only when I can't sleep or when I am sleeping. I had a really weird dream that I was chasing a pink rabbit. I was trying to catch the damn pink rabbit and it was huge. I think it's funny— I'm laughing in the dream, going, "I can't believe this pink bunny!" And then, the pink bunny runs into the street and I'm wondering, "Why is the pink bunny in the street?" And I stop, and the pink bunny gets hit by my Humvee. I see myself in the vehicle and I realize that the pink bunny is the bomb.

So sometimes my dreams aren't necessarily reliving the experience. They're some kind of distortion, how I find ways to cope with the things that are really uncopable. There's really no easy way to get around them.

Starlyn Lara currently works as a Human Resources/Accounts Payable Assistant at Swords to Plowshares, a non-profit veterans organization that provides numerous services for veterans in need; and as a part time Emergency Medical Technician.

This text was condensed and edited from interviews conducted by Jennifer Karady in January 2010.

STEVE PYLE

This is the story of my survival day: May 1, 2003, Mosul, Iraq. After a routine patrol my team became engaged in small arms fire while clearing some buildings in an area near an abandoned airport. When I heard the fire, I was approximately 600 yards in the opposite direction of my men. I positioned myself to identify the fire and saw my men taking fire from an area of buildings across the way. From my position I could see beyond the source of fire where there were Iraqi Nationals running out of the back building beyond the sight of my team so I maneuvered myself to their position to assist. We needed to get back to the Humvee in order to get out of the area. We popped smoke, my team ran as I pulled cover fire. Once they were in position I threw smoke again and ran for the Humvee. The small arms fire had somewhat ceased when the mortars started. They were blowing up all around me when I was thrown into an Iraqi troop carrier and sustained a severe head injury. I was knocked out for a few seconds. I knew I had been injured badly. The top of my head had been smashed and several bones in my right foot were broken. I looked up and around for my guys and saw two men running towards me which appeared to be my team so I laid back and waited for help. Within the next few seconds, I was attacked by two Iraqi Nationals. They were kicking and hitting me repeatedly. Obviously they had no weapons and were attempting to kill me and take mine. One of them tried to take the bayonet affixed to the chest of my fragmentation jacket. It was at that time that everything seemed like slow motion. I remember thinking if I didn't stop them I was going to die, so I did what I had to do to disable these two guys beating on me. I used my bayonet on the guy directly on top of me and then engaged the other man who had been kicking me. It was then that I realized that my men had to leave the area due to the strength in numbers of the fast-approaching enemy. I believe they thought I had been killed so they did what they had to do to survive. I hid under some blown up building debris for approximately six hours before I was picked up. My team returned with backup to search for me. I received medical care from a medic and was flown by Blackhawk to Baghdad. Baghdad was under heavy fire at that time so it took several hours to get me in the air to Kuwait. After being hospitalized in Kuwait I was flown to Germany and finally back home to the U.S. It was by the Grace of God and a few good soldiers that I survived that day.

Steve Pyle sustained a traumatic brain injury and other permanent injuries as a result of this incident. He now serves as Commander of his local chapter of the Military Order of the Purple Heart.

This text was condensed and edited from interviews conducted by Jennifer Karady in December 2009 and July 2006.

AUTHOR BIOGRAPHIES

SUSANNE SLAVICK

Susanne Slavick is an artist whose imagery relies on sources ranging from antiquated cartography to Persian miniatures to Internet documentation of sites in conflict. With the crossed eyes of a realist and idealist, her recent paintings and works on paper are gestures of recognition, remorse and recovery in the face of devastation. Recent works from her ongoing "R&R(…&R)" and "Horsepower Hubris" series have traveled to the Andy Warhol Museum in Pittsburgh, Rutgers University, the Chicago Cultural Center, Bradley University, Zolla Lieberman Gallery at Art Chicago and the McDonough Museum of Art in Youngstown, Ohio.

Slavick graduated from Yale University, subsequently studied at Jagiellonian University in Krakow and earned her MFA at Tyler School of Art in Rome and Philadelphia. She lives and works in Pittsburgh, Pennsylvania, where she is the Andrew W. Mellon Professor of Art at Carnegie Mellon University. Slavick has received a fellowship from the National Endowment for the Arts and four awards from the Pennsylvania Council on the Arts. Her 2010 residency at Blue Mountain Center in New York focused on the costs of war and contributed to the conceptual and creative development of OUT OF RUBBLE.

HOLLY EDWARDS

Holly Edwards holds degrees from Princeton University (BA), the University of Michigan (MA) and the Institute of Fine Arts, NYU (PhD). She currently teaches Islamic art at Williams College in Massachusetts. Her classes cover a broad spectrum of art and architecture in the Muslim world, and her research has been wide ranging, touching on topics as diverse as commemorative architecture in the Indus Valley, Afghan photography and Qur'anic epigraphy. Much of her scholarship has taken the form of museum exhibitions, including *Noble Dreams, Wicked Pleasures: American Orientalism, 1870-1930* (Sterling and Francine Clark Art Institute; Princeton University Press, 2000) and *Beautiful Suffering: Photography and the Traffic in Pain* (Williams College Museum of Art; University of Chicago Press, 2007).

 CHARTA

To find out more about Charta,
and to learn about our most recent
publications, visit

www.chartaartbooks.it

Printed in May 2011
by Leva, Sesto San Giovanni (MI)
for Edizioni Charta